DRAW & PAINT

Fantasy Females

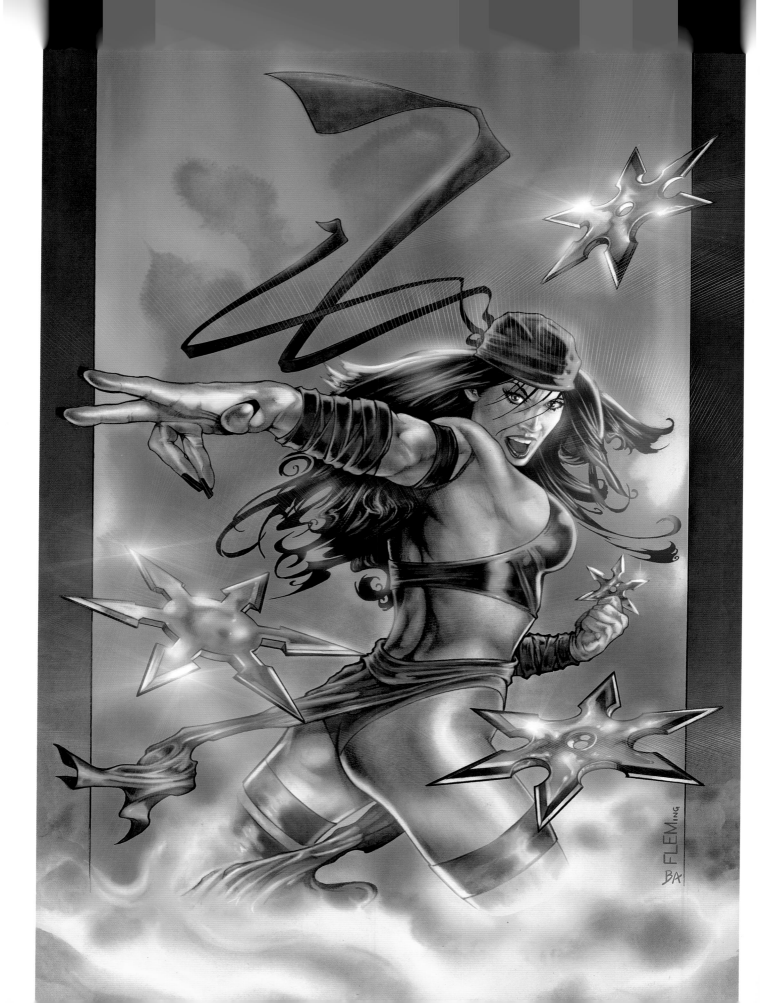

DRAW & PAINT

Fantasy Females

TOM FLEMING

IMPACT

Dedication

To my true fantasy female, my wife Christa, who has been a monolith of support, love and inspiration beyond words written or spoken.

A DAVID & CHARLES BOOK
Copyright © David & Charles Limited 2009

David & Charles is an F+W Media Inc. company
4700 East Galbraith Road
Cincinnati, OH 45236

First published in the UK and US in 2009

Text and illustrations copyright © Tom Fleming 2009

Tom Fleming has asserted his right to be identified as author of this work in accordance with the Copyright, Designs and Patents Act, 1988.

A catalogue record for this book is available from the British Library.

ISBN-13: 978-1-6006-1305-0 paperback
ISBN-10: 1-6006-1305-5 paperback

Printed in China by Shenzhen Donnelley Printing Co. Ltd.
for David & Charles
Brunel House Newton Abbot Devon

Senior Commissioning Editor: Freya Dangerfield
Editor: Bethany Dymond
Assistant Editor: Kate Nicholson
Project Editor: Ame Verso
Art Editor: Martin Smith
Production Controller: Kelly Smith

Visit our website at www.davidandcharles.co.uk

David & Charles books are available from all good bookshops; alternatively you can contact our Orderline on 0870 9908222 or write to us at FREEPOST EX2 110, D&C Direct, Newton Abbot, TQ12 4ZZ (no stamp required UK only); US customers call 800-289-0963 and Canadian customers call 800-840-5220.

Picture Credits

Amy Fadhli: pages 47**br**; 116**t**.
Arcana Studios: 'Ezra' pages 52–53; 56**r**; 60**r**; 114, trademark used with permission.
Asia Carrera: pages 17**bl**; 28**tl**; 43**tl**; 109.
Devin Devasquez (www.devindevasquez.com): pages 6**b**; 34**l**; 39; 40**t**; 42**bl**; 43**tl**; 47**tl**; 54**t**; 82–89.
Harris Publications Inc.: 'Vampirella' pages 12**tl**; 19**bl**; 40; 112; 113, registered trademark used with permission.
Marvel Comics: 'Elektra' pages 2; 8; 22–23; 46**br**; 50**bl**, 50**r**; 62**bl**; 110; 111; 128; 'Mystique' page 50; 'Dazzler' page 57; 'Wasp' pages 56**t**; 58; 'Spiral' page 63; 'Shadowcat' page 115; 'White Queen' page 61**r**. These characters are trademarks of Marvel Entertainment Inc. used with permission. All Elektra images digitally coloured by Brad Anderson, except page 8 digitally coloured by Dean White.
Neil Gaiman (owner of 'Angela'): pages 50**tl**; 62**tr**, used with permission.
Radio Repertory Company of America: 'Ring of the Minotour' pages 51**bl**; 61**l**, used with permission.
Seffana: pages 34**c**; 47**bl**; 64–65; 90–97.
Shae Marks (www.shaemarks.com): copyright photo of Devin Devasquez pages 34 and 83, used with Devin's permission.
Stacy E. Walker (www.stacyewalker.com): pages 24**tl**; 34**tl**; 38**t**; 42**br**; 47**tl**; 74–81; 108.
Teri Byrne: pages 21**br**; 34**t**; 47**tr**.
White-Wolf Publishing: 'Heralds of the Storm' page 124, trademark used with permission.
Victoria Zdrok: page 7**t**.

Key
b - below
t - top
r - right
l - left
c - centre

Contents

Introduction

The Fairer Sex

The role of the female in fantasy art has evolved over many centuries. The Greeks and Egyptians can be credited with the invention of fantasy art, with depictions of their deities in paintings and sculptures. The first fantasy females were these ancient goddesses – they were mostly maternal in nature, with the exception of a few, such as Diana, goddess of the hunt. Through the ages women have been portrayed as demure, gentle and beautiful, but the idea of them being strong and empowered did not come about until much more recently.

A very quick pen and ink sketch that gives a feel for a dynamic pose.

Today the fantasy female is liberated, powerful and dangerous while maintaining her inherent sensuality. This is why females are the most popular of all fantasy art and comic book subjects, because women can admire their strength and independence while men can appreciate their beauty and sexuality.

Female figures fall into several different categories within the fantasy genre. There are many classic archetypes such as the vampire or succubus, the faerie or nymph, the angel, the witch or sorceress, the warrior, the mermaid, the pin-up, the goddess and the demon or devil, to name but a few. When drawing or painting a fantasy female there really are no rules except that the subject must stimulate a sense of the unreal. This visual

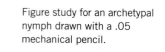

Figure study for an archetypal nymph drawn with a .05 mechanical pencil.

reaction can come from the character's sensuality, strength, pose, costume, facial expression, environment or even a distortion of her anatomy.

My own interest in fantasy art came from a childhood fascination with comic books. I started by copying my favourite superheroes directly from the comic pages, but quickly developed a preference for the greater realism of fantasy art over the stylization of comic book art. I am also a big fan of pin-up art and thought it would be great to combine the two genres.

I was probably around the age of 14 when I discovered the work of Frank Frazetta, Boris Vallejo and Michael Whelan and since then there has never been a moment that I have wanted to do anything else with my life. After all, what red-blooded male wouldn't want to draw and paint beautiful women for a living?

This book starts with the basics of sketching and drawing and works its way up to more advanced painting techniques. Using practical lessons and clear step-by-step demonstrations you will be able to follow the process of creating dynamic and convincing images of fantasy females. Most of the advice is traditional and therefore great for beginners and intermediates, but I also cover some of my tricks and techniques that will be of interest to more advanced artists, too.

Ultimately, the best advice I can give when creating fantasy females is to be sincere and passionate, take risks and do what appeals to you first and foremost with your own unique take.

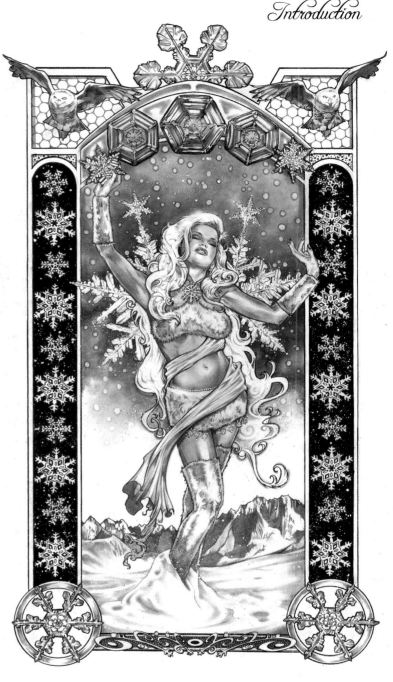

Venus
A panoramic-format mixed media image created with watercolour, pencil, acrylic and gold doily.

Winter
Fully rendered pencil drawing on Bristol paper. One of a set of limited edition prints of the four seasons.

Elektra
The cover image for issue 31 of the famous Marvel comic and also used as the trade paperback cover. This is one of my favourites of the Elektra images featured throughout this book.

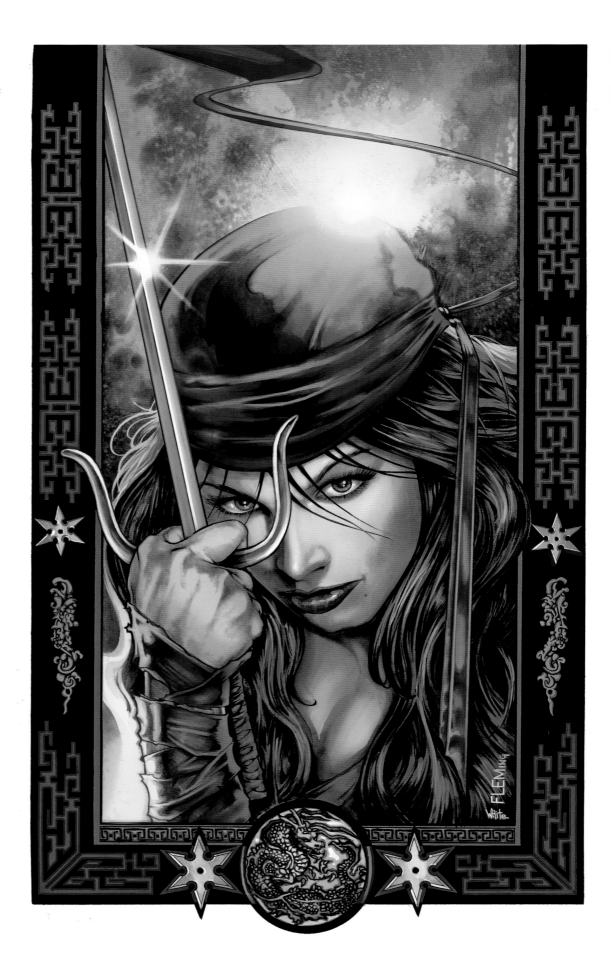

PERCEPTIONS OF FEMALE BEAUTY THROUGH HISTORY

The definition of physical perfection has changed significantly throughout the ages. From the plump, cellulite-ridden beauties depicted in Rubens' 17th-century painting *Three Graces* to the modern-day 'size zero' supermodel, there has been a massive change in perception in terms of what the ideal female form should look like.

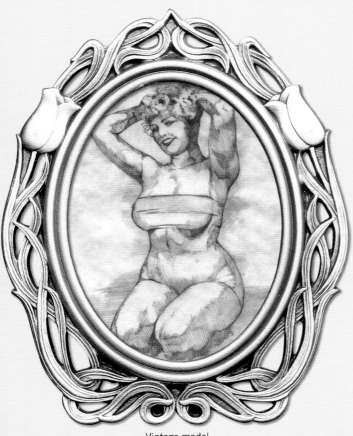

Vintage model

Modern-day model

Even in the 20th century, the shift has been dramatic. The 1920s saw the rise of the 'flapper girl', with waif-like, boyish features being the pinnacle of beauty. In the 1940s and 50s a fuller, more feminine figure was popularized by pin-ups such as Marilyn Monroe and Bettie Page. The 1960s saw a return to the super-skinny, epitomized by Twiggy. This trend came and went throughout the rest of the century, and has returned full-force in the early 21st century, as seen on fashion runways around the world.

When it comes to fantasy females, however, 'underfed' is not the preferred look, and most men agree that a modern-day fantasy female should have slightly more meat on her bones. The two illustrations above reveal some of the most crucial differences between a fantasy female of the early-to-mid-20th century, and one from today's culture, where sex and nudity is far less of a taboo.

One of the obvious differences is body type. The vintage model has a much fuller, thicker body type. Even her face has a more rounded look to it. She certainly is buxom, but by today's standards she would be considered a 'plus-size' model and might be described as 'chunky'. The modern-day model on the other hand has very little body fat and is very sleek, without being too thin.

Their bathing suits and poses also reveal some crucial cultural differences. The vintage model has a one-piece suit that covers the hips and stretches across the breasts. She sits in a modest, 'safe' pose with a charming smile, which is only vaguely suggestive. The contemporary model on the other hand wears a skimpy bikini that leaves very little to the imagination. Her arched back, head back and long flowing hair is much more erotic and suggestive, which appeals far more to today's audience.

Chapter 1

Female Basics

The female body is undoubtedly a thing of great beauty but when it comes to fantasy females nothing less than perfect will do. This chapter gives you a solid foundation by exploring the fundamentals of ideal proportions, revealing how to create beautiful bodies and faces, and explaining how to render feminine hands and feet.

Dragonfly (detail)
An Art Nouveau-inspired fully rendered pencil drawing created as a limited edition print.

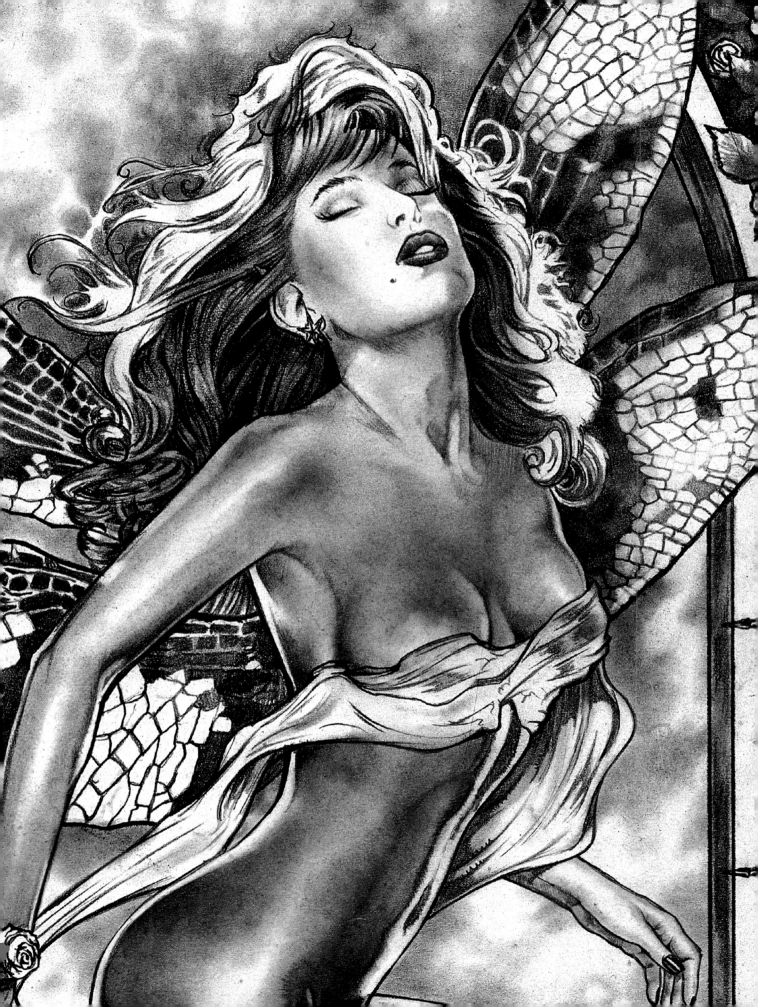

The Female Body

Vampirella is a registered trademark of Harris Publications, Inc. used with permission.

Curvaceous and shapely or slim and boyish, the female body has been inspiring artists for millennia. From the majestic, elongated representations of Queen Nefertiti scribed on Egyptian tomb walls, to the muscular curves of Lara Croft in modern-day games and movies, the female form is endlessly fascinating and yet presents numerous challenges to those trying to capture it.

Assessing proportions

When drawing the human body, whether male or female, the single most important thing to be aware of is proportion. What this means is the overall size of the figure and the size of the different body parts in relation to each other. Learning the correct proportions thoroughly will give you the ability to draw a figure realistically, or to exaggerate those proportions in a stylized manner for a specific look or effect.

When it comes to calculating the proportions for the overall size of a figure, the most accepted unit of measurement is the head. Theories differ slightly, but the proportions of the average adult person are around seven heads high. However, as this book is not concerned with average but with fantasy, a scale of eight heads high is a better number for the proportions, and will create a much more dynamic and heroic-looking figure, as the example on the right illustrates.

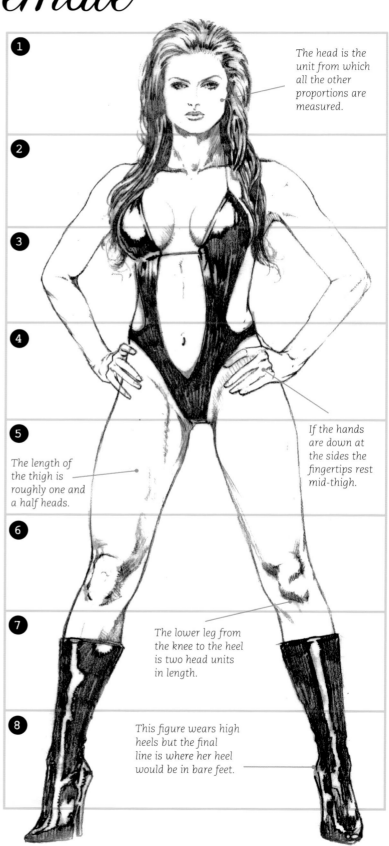

1

2

3

4

5

6

7

8

The head is the unit from which all the other proportions are measured.

If the hands are down at the sides the fingertips rest mid-thigh.

The length of the thigh is roughly one and a half heads.

The lower leg from the knee to the heel is two head units in length.

This figure wears high heels but the final line is where her heel would be in bare feet.

Calculating proportions using heads

In the diagram opposite, the red lines indicate how the head unit has been used to calculate the rest of the figure's proportions. The figure is divided into eight sections that equal the height of the head. The sections break down as:

1. From the top of the head (note, not the top of the hair) to the chin;
2. From the chin to the middle of the breasts;
3. From the breasts to the stomach just above the navel;
4. From the stomach to the crotch;
5. From the crotch to slightly lower than mid-thigh;
6. From mid-thigh to just below the kneecap;
7. From the knee to mid-shin;
8. From the shin to the heel.

The shoulder width will vary depending on how powerful you want the figure to look, but a good starting point is about three heads across.

When calculating proportions for other body parts, the following guidelines are commonly agreed for an adult:
- When standing upright with arms down at the side, the fingertips rest at mid-thigh.
- The span of the arms – from fingertips to fingertips – is approximately equal to the height of the figure. (On the figure illustrated opposite, this is thrown by the fact she is wearing high-heeled boots.)
- The length of the foot is around the same as the length of the forearm.
- The length of the shin equals the length of the hip.

The female skeleton

The female and male skeletons are fairly similar, but there are key differences that are important to grasp in determining your figure's proportions. Women have a smaller rib cage, narrower shoulders and slightly larger pelvic bone. Understanding the skeletal framework is crucial to getting a feel for how your figures hold themselves and move around, which in turn informs how you should render their musculature.

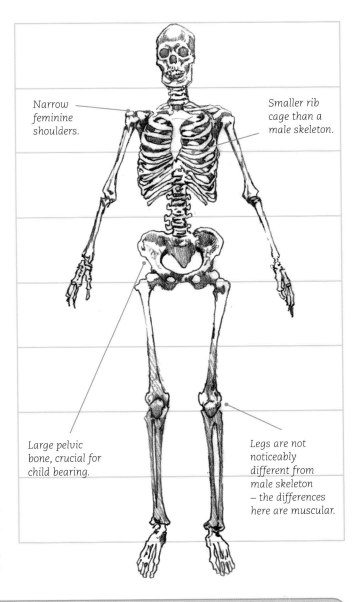

Narrow feminine shoulders.

Smaller rib cage than a male skeleton.

Large pelvic bone, crucial for child bearing.

Legs are not noticeably different from male skeleton – the differences here are muscular.

OBSERVING THE FIGURE FROM REFERENCES

The human anatomy is extremely challenging to draw but it is the foundation of fantasy art. Observing the figure in reference sources makes the task a lot easier than using your imagination alone.
- Looking in a mirror at your own anatomy is the first and most basic form of reference.
- Taking pictures of friends and family in different poses, or asking them to shoot pictures of you, is a great way to get postures to sketch out later.

- Look at anatomy books in your local library.
- Health and fitness magazines are good for observing musculature.
- Fashion magazines will help you see how clothes hang on the female figure.
- Search the Internet for inspiring images.

So, gather together as much data as you can, spend time observing, then fill up your sketchbooks and don't worry about creating amazing finished artwork.

Back to Basics

This simple demonstration will help you to draw a basic figure in four easy steps.

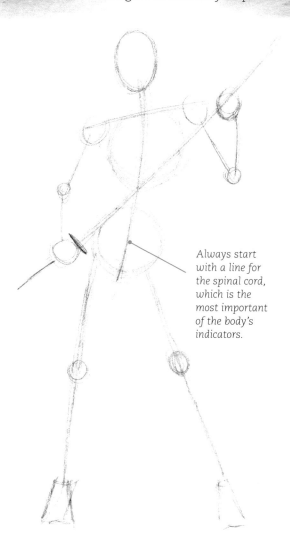

Always start with a line for the spinal cord, which is the most important of the body's indicators.

You could use cylindrical shapes, which some artists prefer, but I find ovals work nicely, particularly for curvy female figures.

Step 1:

Draw the figure in geometric shapes

Break down the body into geometric shapes and create a stick figure of the pose. Use an oval for the head, a circle for the upper torso and a circle for the hips. Draw a line perpendicular to the spine for the shoulders. Add smaller circles to indicate the shoulder joints then add the arms, using small circles for the elbows, wrists and hands. Plot out the legs, and add small circles for the knees and ankles and triangles for the feet.

Step 2:

Flesh out the figure

Develop your stick woman using oval shapes. First, flesh out the upper torso and hips by creating a kidney or bean-like shape to fit around the circles you drew in Step 1. Then add oval shapes around the other lines for the arms and legs. You will quickly see the figure start to take form. Make sure you have indicated where the hands are positioned using squares or circles.

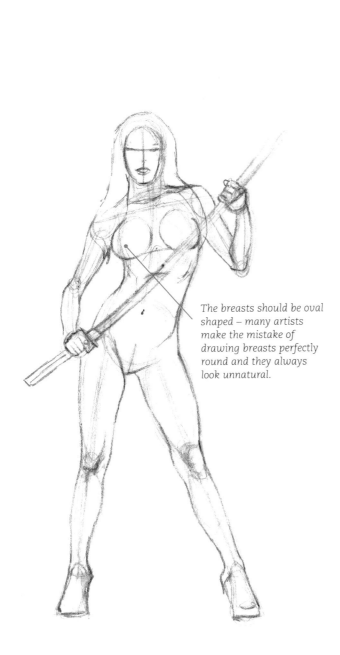

The breasts should be oval shaped – many artists make the mistake of drawing breasts perfectly round and they always look unnatural.

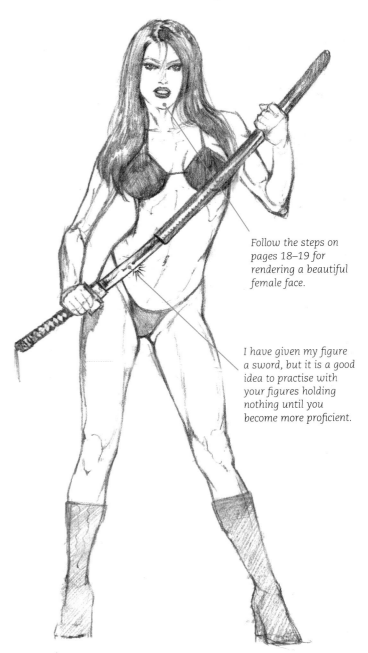

Follow the steps on pages 18–19 for rendering a beautiful female face.

I have given my figure a sword, but it is a good idea to practise with your figures holding nothing until you become more proficient.

Step 3:

Add form and detail

Give the figure form and musculature, based on your knowledge of anatomy. Indicate the breasts with ovals, angling them slightly outwards. Next find the navel and crotch. When the key anchors are in place, start adding details and anatomical shapes to the figure. Draw the hair outside the skull shape and plot in the facial features following the advice on pages 16–17.

Step 4:

Final image

Decide which lines you like and make them bolder, and then erase the distracting lines. All the other details such as eyes, lips, hair, costume and muscle forms are developed now – these elements are all discussed in subsequent pages. Refer to each section of the book, follow these basic steps, build up slowly and practise. You will be drawing your own fantasy females in no time!

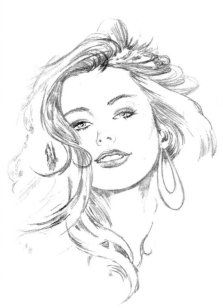

The Female Face

What is it that makes a face beautiful? The age-old saying 'beauty is in the eye of the beholder' is true in that everyone has their own personal preferences on aesthetics. However, there are general guidelines to the proportions of a face that the *majority* of people do regard as beautiful.

Gorgeous features

In order for a face to be considered attractive, it needs to demonstrate symmetry. Symmetrical features create a harmonious, pleasing effect. While some people prefer the natural look, this is not appropriate in fantasy art – our task is to create idealized females not real-world ones. Other factors that contribute to the beauty of a face include long lush eyelashes, a flawless complexion, thick flowing hair, full glossy lips and pearly white teeth. However, the first job is to establish the correct facial proportions, as explained by the diagrams that follow.

Front view
- From the front, the general shape of the head is egg-like, tapering slightly at the bottom.
- Box in the egg shape to get a rectangle and divide it evenly into four parts (shown by the red lines).
- Place the eyes directly on the halfway mark with one eye's width in between them (shown by the blue lines).
- The mouth lies about one-third up from the base of the rectangle to centre line.
- The nose lies on the vertical halfway point and is usually slightly less than one eye's width from nostril to nostril.
- The width of the mouth can be determined by drawing a triangle running from the direct centre of the face past the edge of each nostril (shown by yellow lines) and down to its placement one-third up from the base of the rectangle.
- The ears should be drawn in slightly lower than the horizontal centre line.

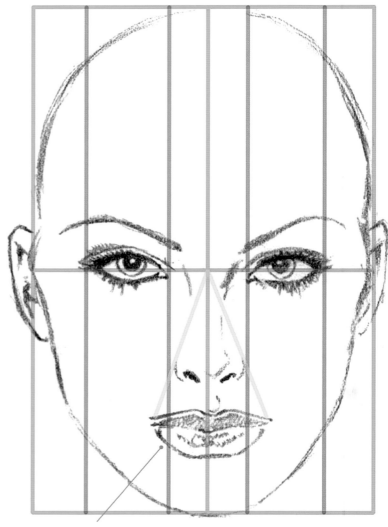

The lower lip is usually fuller than the upper lip and is slightly recessed.

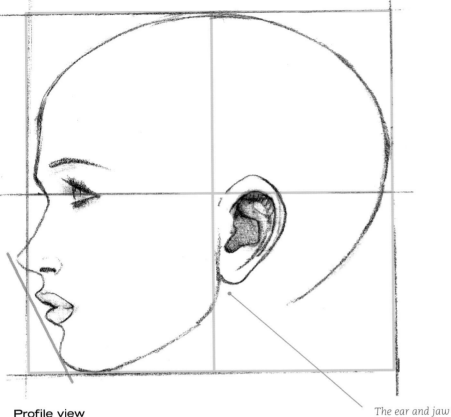

Valkyrie (detail)
This is a classic-style face with very even features. The lips are a bit thinner than average to avoid a 'pouty' pin-up look and achieve a determined expression. Her hair was drawn up for classical appeal, while letting little wisps of hair fly around to give the sense that, as hard as she tries, she can't restrain her sexuality.

Profile view
- In profile, do the same thing as the front view, only this time use a square instead of a rectangle.
- Divide the square into four equal sections from the flat plane of the forehead to the back of the head.
- The eyes are placed on the halfway line. The same distances apply for the mouth and nose as in the front view (see opposite).
- The blue line shows an important feature to drawing a pretty face – make sure the mouth, nose and chin all align on an inward angle with the upper lip protruding slightly from the lower lip.
- A gentle slope to the nose with a little tilt upwards always creates a pleasant profile.
- Make sure the nostrils are not too large – a mere indication is all that is necessary.
- A pleasant curve to the forehead is important, along with making sure the brow does not protrude too far.
- The eyebrow should curve around the eye and then angle slightly down towards the brow.

The ear and jaw lines start on the vertical centre line, with the ear placed slightly lower than the horizontal halfway point.

Lion Queen (detail)
The intention here was to create an innocent but slightly 'goth' feel to this face. The shape of the face is rounder with less angles and a very tapered jaw line. To get the goth feel, but maintain her innocence, I made the eyes larger than normal, with dark eyelashes to contrast with her blonde hair, which falls into her eyes.

Using a point of highlight in the centre of the bottom lip gives a high-shine 'lip gloss' finish.

Dragon Mist (detail)
This is a good example of how features differ depending on ethnicity. The front plain of the Asian skull is slightly flatter than in most other cultures. Her beautiful cat-like eyes, angled slightly upwards, are a key Asian feature. Her nose has very little slope and has a rounder, less pointy look than the average Caucasian nose.

Back to Basics

This demonstration shows you how to create a pleasing female face in six simple steps.

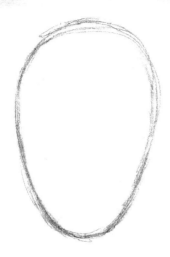

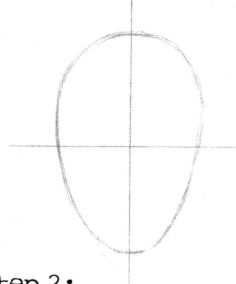

Step 1:

Draw the initial shape

Start by drawing the outline – a basic egg shape – making sure that it tapers at the bottom for the chin.

Step 2:

Find the centre lines

Find the centre lines, both vertical and horizontal, and draw these in to guide you in placing the facial features correctly.

For a more exotic look, angle the ovals for the eyes slightly, making the outer edges point upwards.

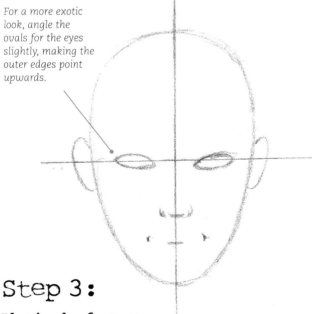

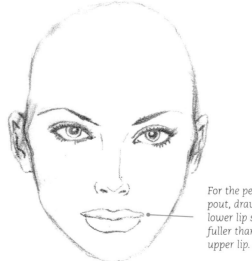

For the perfect pout, draw the lower lip slightly fuller than the upper lip.

Step 3:

Plot in the features

Follow the detailed advice on page 16 to find the locations of the facial features – eyes, nose, mouth and ears – and plot these in on the face.

Step 4:

Add the details

Erase your guidelines and add details such as eyebrows, eyelashes, pupils and lips. Make the lower lip fuller than the upper lip and keep the nose and nostrils petite.

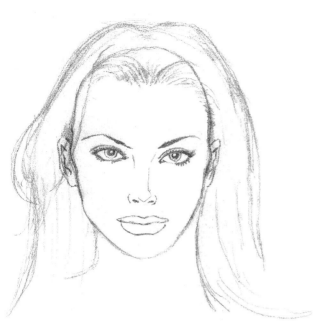

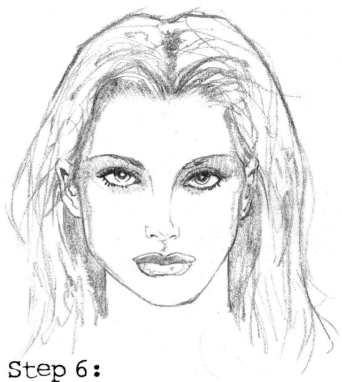

Step 5:

Block in the hair

Since hair does not cling directly to the scalp unless it is wet, make sure you sketch in the hair outside of the oval of the face for a more full-bodied look.

Step 6:

Final image

Continue to develop the hair and refine the features until you are satisfied. Here is the finished sketch of the face – a real beauty created in just a few minutes' work. Practise these steps in your sketchbook as many times as you need to until drawing faces becomes almost second nature.

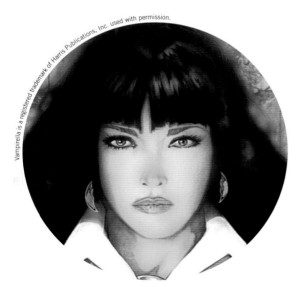

Vampirella (detail)

This face is a great painted example of the build up shown in this basic demonstration. She has a beautiful pin-up style face with an icy cold stare. Much of the focus of this face is on the realism of her lips and eyes. Her stark black hair in contrast with her green eyes makes for a stunning look.

TOP TIPS FOR FACES

- *Use a minimum of lines, especially around the nose and eyes, as any visible lines could be interpreted as wrinkles.*
- *Be careful to make the width of the nose and the nostrils petite.*
- *Eyelashes should be treated as a single volume, not as individual strands.*
- *Take care not to make the jaw line too strong, as this is a very masculine trait.*
- *When drawing the eyes, be very careful where you place the highlight; the slightest miscalculation can cause your face to look cross-eyed or lazy-eyed.*

Hands and Feet

The way you use or position hands and feet in a drawing or painting is, along with facial expression (see pages 44–47), one of the most important factors in establishing a feeling or mood for your figure. The arrangement of hands can show your character's strength or reveal her tenderness, and the position of the feet can lend an air of grace to your figure, or give her a strong, grounded feel.

Geometric shapes

Most people believe that hands and feet are very difficult to draw and paint, and unfortunately they are correct – the only real way to succeed is years of practise. The best way to practise is to get a digital camera, shoot lots of reference photos of your female friends' hands and feet in different positions, and get drawing.

Use your references to observe how hands and feet can be broken down into simple geometric shapes to help create the more complex forms. The following examples demonstrate the different shapes that can be used.

Leopard Girl

Here you can see how the hand has been developed from basic geometric forms, into a more detailed sketch and into the final image. The hand position reveals this magnificent creature's affinity with nature, while the claw-like fingernails show her wild side.

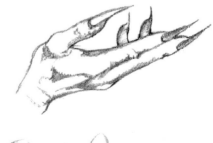

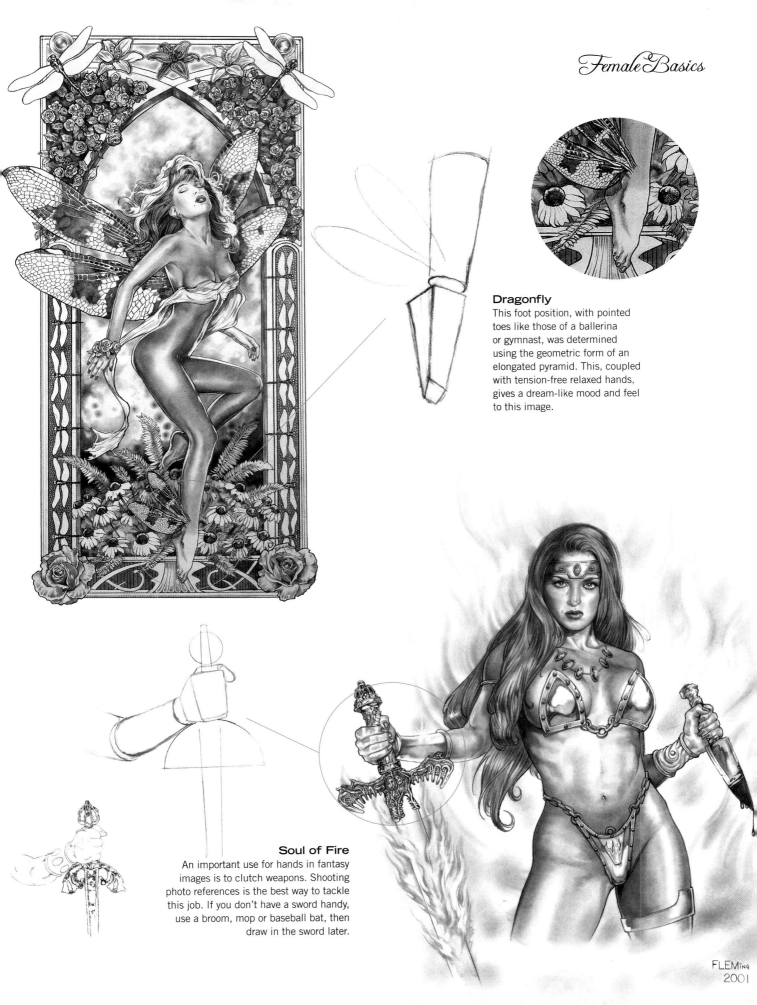

Dragonfly

This foot position, with pointed toes like those of a ballerina or gymnast, was determined using the geometric form of an elongated pyramid. This, coupled with tension-free relaxed hands, gives a dream-like mood and feel to this image.

Soul of Fire

An important use for hands in fantasy images is to clutch weapons. Shooting photo references is the best way to tackle this job. If you don't have a sword handy, use a broom, mop or baseball bat, then draw in the sword later.

FLEMing
2001

Chapter 2
Drawing and Painting

With the essentials of anatomy sorted, it is now time to move on to the equipment and techniques required for rendering fantasy females in pencil and paint. This chapter gives you a basic tool kit for drawing and painting, and reveals how these tools can be used to create some interesting and unusual effects.

Elektra (detail)
The comic book heroine with ninja throwing stars. This composite image reveals the pencil tones underlying the finished painting.

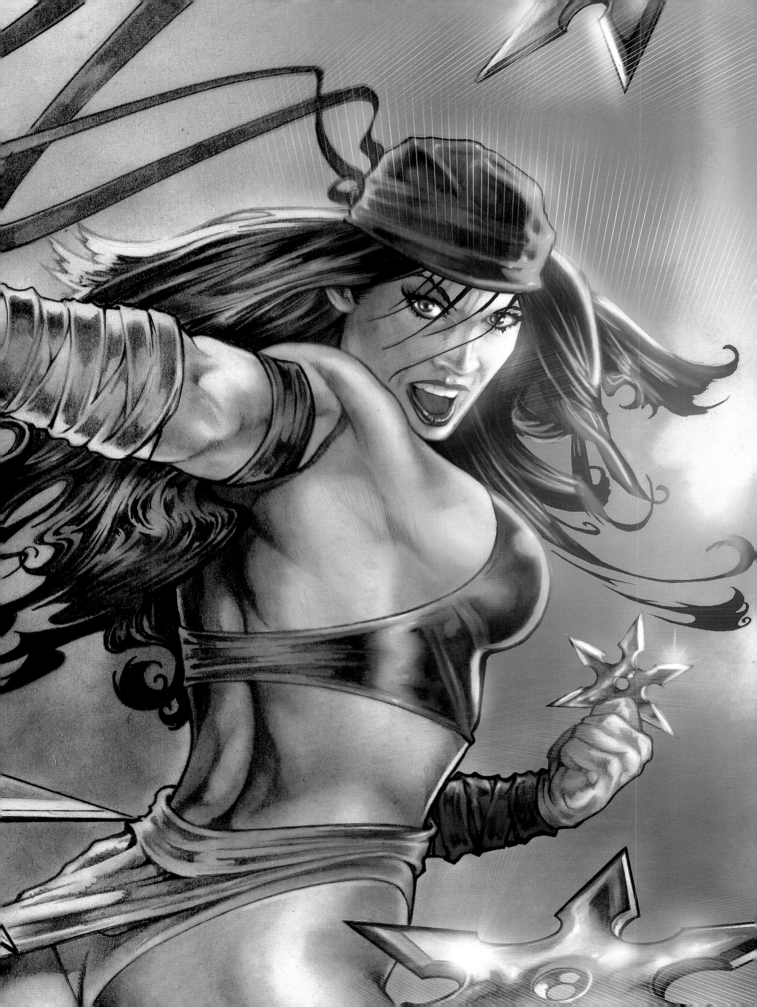

\mathcal{D}rawing

I have always had a preference to add colour to my images. It wasn't until quite late in my career that I discovered blending stumps, which opened up a whole new world of possibilities for pencil-only images. Monochrome drawings speak to the viewer in a different way to colour images, in the same way that a black-and-white photograph is often more powerful than a colour shot. Using simple pencil lines and shading techniques to create fantasy females is a delicate art, which this section will explore.

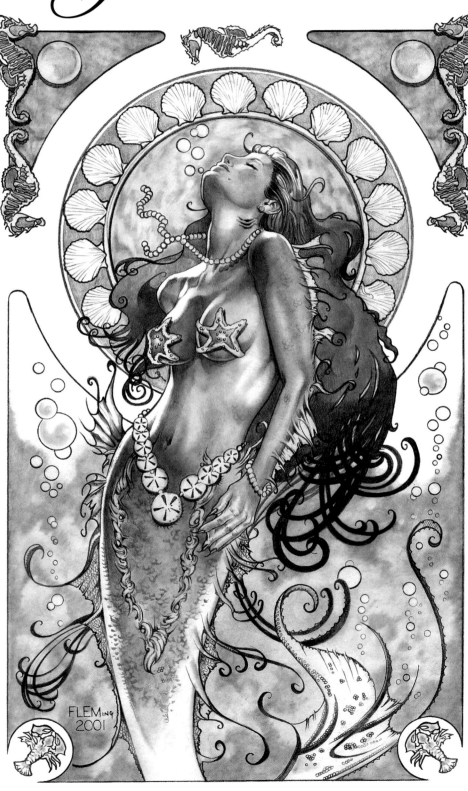

Mermaiden
This striking image is drawn in an Art Nouveau style, using pencils and blending stumps alone. It has just as much impact as a full-colour image, brought about through sinuous and flowing stylized lines combined with realistic rendering and shading, which complement each other beautifully.

Drawing supplies

The tools you use for your artwork will depend on personal preference, budget and skill level. Here are the supplies that I use every day. As a basic drawing toolkit, you can't go too far wrong with this.

Kneaded eraser – *absorbs the pencil instead of rubbing it into the paper like most other erasers do.*

Click eraser – *for erasing hard-edged areas such as outlines, borders and highlights.*

Used soft cloth – *for very large areas of smooth tones; residual graphite left on it is great for subtle shades without laying down pencil.*

Clean soft cloth – *to lighten and smooth areas without using an eraser.*

.03 mechanical pencil – *for very fine pencil work such as facial features.*

.05 mechanical pencil – *for medium/general pencil work.*

.07 mechanical pencil – *for thicker areas such as shading, outlines and borders.*

8B pencil – *for super dark areas and absolute blacks.*

6B pencil – *for dark areas, but not absolute blacks.*

No. 8 blending stump – *for large areas of shading and blending.*

No. 4 blending stump – *for medium areas of shading and blending.*

No. 2 blending stump – *for fairly small areas of shading and blending.*

No. 1 blending stump – *for fine areas of shading and blending.*

Drawing techniques

The art of drawing is one that takes determination, experimentation, patience and above all practise. The following swatches demonstrate some of my key techniques for shading, blending and creating texture in drawings – revealing some of the most interesting effects that can be achieved with pencil, graphite and erasers. Try them out for yourself to see how they can be incorporated into your own work.

1. Simple blending
This is the most straightforward of blending techniques. A soft cloth with graphite powder is rubbed in circles creating a nice even, smooth tone.

2. Drawing with a stump
Drawing with the larger No. 8 blending stump with residual graphite on it is great for soft-edged lines that you just cannot get with a pencil, no matter how soft.

3. Smoothing and blending
Here's how to smooth and blend harder edged pencil marks. Take a .07 pencil and shade the top half of the square leaving obvious pencil strokes. Then take a medium-sized blending stump and rub with a fair amount of pressure (where you see the darker area), and then reduce the pressure to get a lighter blend.

4. Mimicking a wash
This is a more advanced technique and one worth mastering. Repeat the initial step for Swatch 1, then take a No. 4 blending stump with a decent point and rub in 'U' or 'W' shaped motions all along the edge where the tone meets the white paper. This results in an effect that is similar to the way watercolour bleeds into wet paper.

5. Lifting out
You can use an eraser to lift a hard-edged line off the paper after a tone has been laid down. First repeat Swatch 1, then use a click eraser to erase some of the graphite to leave a lighter area. After erasing, always use a brush to wipe off the eraser residue to avoid getting skin oils on the paper.

6. Using an eraser for texture
In this swatch you can see how you can create textures by pulling some tone back off of the paper using a kneaded eraser. Repeat Swatch 1 then 'smoosh' a kneaded eraser into the tone with a repeated dabbing motion, pulling it up quickly to leave behind this great textured effect.

7. Smoky effect
To create this smoky effect, do exactly the same thing as Swatch 6, but swipe the eraser across the tone while twisting it, to get the thick/thin effect of smoke flowing across the page.

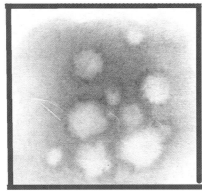

8. Mystical bubble effect
Another wonderful effect – again repeat Swatch 1, then shape your kneaded eraser to a blunt point and erase different-sized circles. Then pick up your No. 4 and No. 2 blending stumps and lightly blend the outer edge of the circle, which darkens the tones, leaving a bubbly/waterdrop effect.

9. Rich black tones
To get a really dark tone, take an 8B pencil and shade in one direction, which makes for a nice dark tone. However, due to the soft quality of the lead, streaks and pencil marks are still apparent. To eliminate the marks and get a richer black, just take your 8B and shade in the exact opposite direction, pressing firmly. You now have a pure black tone. A blending stump can be used to smooth it out even further.

Cowgirl
This pin-up drawing with a Western theme features many of the techniques shown in the swatches. It was created using pencils, blending stumps, a soft cloth and an eraser.

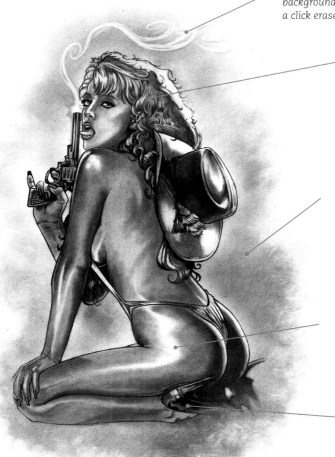

The swirls of smoke were lifted out of the background tone using a click eraser.

The tones in the hair were created by drawing and shading with blending stumps.

The background tone was laid down using graphite powder on a soft cloth.

A blending stump was used to create smooth gradation in the skin tones to avoid any blotchiness.

The rich blacks were rendered with a soft 8B pencil.

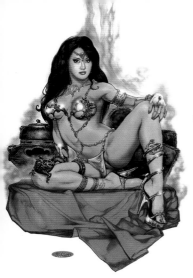

Painting

No matter how long you have been painting and how much you have learned, there are still unlimited aspects of the technique still to be discovered. Painting is a language in itself and colours are the words. Stated the right way, paintings can tell stories that are larger than life. This section gives you an introduction to the world of painting, which can be one of the most satisfying artistic experiences in the world.

Painting supplies

As with the drawing supplies, the tools you use for painting will be based on your own personal choices and the style of your work. These are the tried-and-tested materials that I use in my own studio – no matter what you use, a good selection of different brushes that you feel confident and comfortable using is essential.

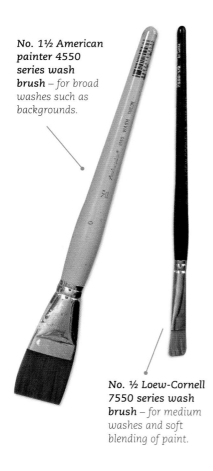

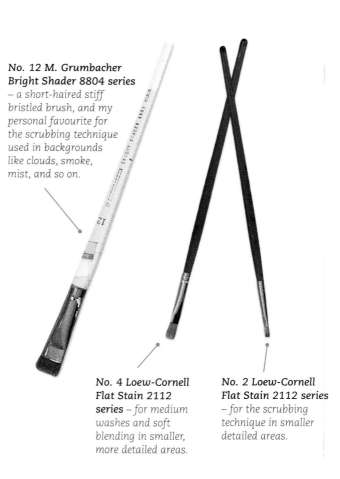

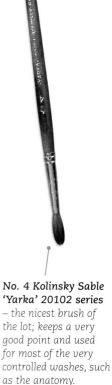

No. 1½ American painter 4550 series wash brush – *for broad washes such as backgrounds.*

No. 12 M. Grumbacher Bright Shader 8804 series – *a short-haired stiff bristled brush, and my personal favourite for the scrubbing technique used in backgrounds like clouds, smoke, mist, and so on.*

No. 4 Kolinsky Sable 'Yarka' 20102 series – *the nicest brush of the lot; keeps a very good point and used for most of the very controlled washes, such as the anatomy.*

No. ½ Loew-Cornell 7550 series wash brush – *for medium washes and soft blending of paint.*

No. 4 Loew-Cornell Flat Stain 2112 series – *for medium washes and soft blending in smaller, more detailed areas.*

No. 2 Loew-Cornell Flat Stain 2112 series – *for the scrubbing technique in smaller detailed areas.*

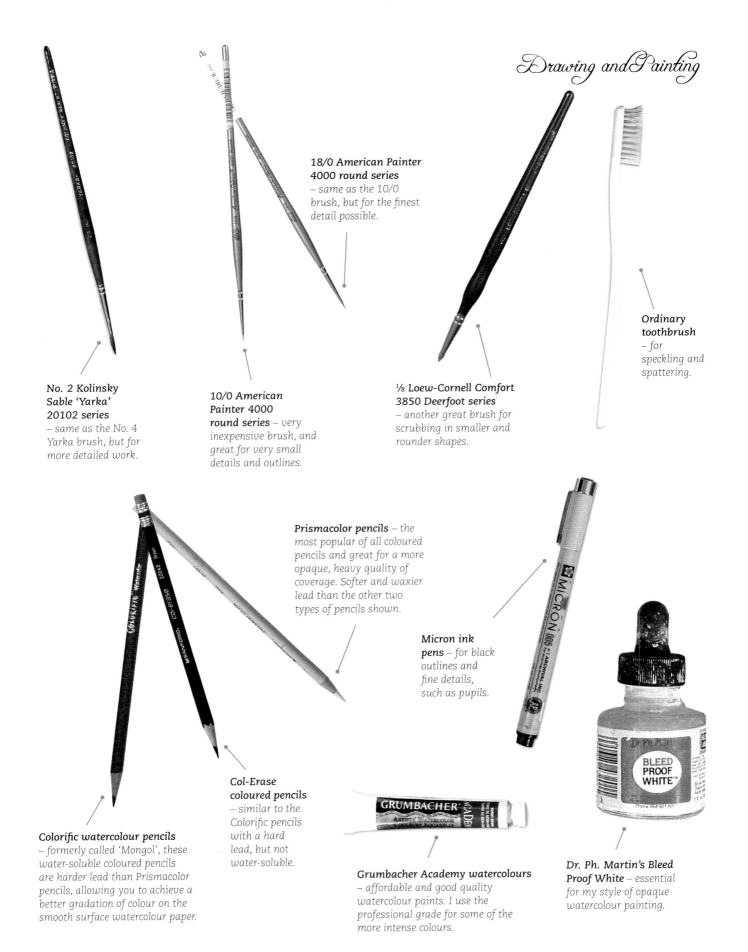

18/0 American Painter 4000 round series – *same as the 10/0 brush, but for the finest detail possible.*

Ordinary toothbrush – *for speckling and spattering.*

No. 2 Kolinsky Sable 'Yarka' 20102 series – *same as the No. 4 Yarka brush, but for more detailed work.*

10/0 American Painter 4000 round series – *very inexpensive brush, and great for very small details and outlines.*

⅛ Loew-Cornell Comfort 3850 Deerfoot series – *another great brush for scrubbing in smaller and rounder shapes.*

Prismacolor pencils – *the most popular of all coloured pencils and great for a more opaque, heavy quality of coverage. Softer and waxier lead than the other two types of pencils shown.*

Micron ink pens – *for black outlines and fine details, such as pupils.*

Col-Erase coloured pencils – *similar to the Colorific pencils with a hard lead, but not water-soluble.*

Colorific watercolour pencils – *formerly called 'Mongol', these water-soluble coloured pencils are harder lead than Prismacolor pencils, allowing you to achieve a better gradation of colour on the smooth surface watercolour paper.*

Grumbacher Academy watercolours – *affordable and good quality watercolour paints. I use the professional grade for some of the more intense colours.*

Dr. Ph. Martin's Bleed Proof White – *essential for my style of opaque watercolour painting.*

Painting techniques

The swatches shown here reveal most of the basic applications that I commonly use. You can see all of these techniques in action in the step-by-step demonstrations that follow later in the book (see pages 66–107). Here, I have tried to simplify each technique so that it can be easily understood, practised and then applied to your own masterpieces.

1. Smooth wash
This is a simple watercolour wash to show how you can get a nice smooth blend by wetting the paper with plain water before laying the colour down. The paper should just be evenly damp, not wet.

2. Streaky wash
This swatch shows the difference of laying down the exact same wash as Swatch 1, but not dampening the paper first. Notice the streaks and uneven watermarks.

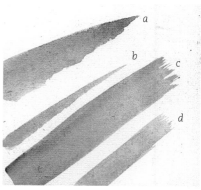

3. Brush marks
This shows strokes from four different brushes. a) No. 4 sable: a thick stroke that tapers to a fine point. b) No. 2 sable: the same as (a) but a much thinner quality. c) No. ½ wash: a broad stroke with a feathered effect at the end. d) No. 4 flat: the same as (c), but much thinner quality.

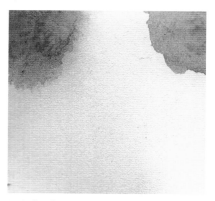

4. Soft edges
This shows how you can soften the edge of a wash after laying it down. Start by laying down an identical wash in each corner. Don't touch the right-hand corner and just let it dry. While the left-hand corner is still wet, wash your brush in clean water, and with the clean wet brush, softly touch the wet edge of the colour, which pulls the paint into the background and softens the hard edge.

5. Additional colours
This swatch shows the same technique as Swatch 4, but using two different colours on top of a base tone. You can see how you can go from a strong colour in each corner, to just a tint of colour over the base tone.

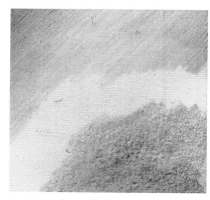

6. Coloured pencils
This swatch shows the difference between a hard-lead coloured pencil such as Colorific, Verithin, or Col-Erase, and a soft-lead coloured pencil such as Prismacolor. The upper left-hand corner is the hard lead – notice the soft gradation. The lower right-hand corner is the soft lead, which has a much thicker coverage, but leaves a more pebbly textured effect.

COMPUTERS AND THE DIGITAL ART REVOLUTION

The art world has changed dramatically in the past 15 years and it is no longer possible to identify paintings that were created digitally and those that were hand-painted. Artists are doing amazing things digitally, and in general it is a faster and more forgiving medium than painting by hand.

I don't paint digitally at all – the only thing I do use the computer for is to add an effect digitally (a rarity) or to adjust the colour and contrast of an image once it has been scanned. The advice given throughout this book is for traditional media and techniques.

While many of the effects in digital painting software have been designed to emulate traditional methods, it is invaluable to be able to understand these processes first-hand. This book is therefore pertinent to artists working in all media, and while it will be most useful to those who draw and paint on paper and canvas, it still has relevance to those working on-screen.

The biggest aspect of art that computers have changed is the business end. Years ago it was very difficult to promote yourself, but now with websites, forums and discussion groups, anyone can give it a go.

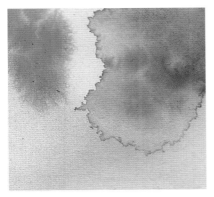

7. Wet on wet
This shows a wet-on-wet technique. Dampen the base tone, then dab spots of colour in the corners. Leave the left-hand corner to dry. Wait a minute, then dab the right-hand corner with plain water. Notice the difference in the edges and the fantastic watery effects that can be achieved.

8. Washing watercolour pencils
This shows how a wash turns watercolour pencil to paint. Shade diagonally across the square with watercolour pencil. Wash plain water two-thirds of the way across. Shade again in the corner; add more water. Note a rich paint effect, then a watercolour wash going into the shaded pencil.

9. Opaque white watercolour
This shows how to tone down effects with a wash of opaque white. Repeat Swatch 7 with a darker colour in two opposite corners. Let dry without touching them. With a flat wash brush and some watery opaque white (it should look like milk), brush back and forth a few times. Let dry.

10. Enhancing with coloured pencil
This swatch shows how you can enhance watercolour strokes or washes with hard-lead coloured pencils. Take a flat wash brush and do two very similarly shaped strokes. Let them dry. Take a pencil that is similar to the stroke colour, and softly darken the edges of the stroke all around it. See how it exaggerates the contrast yet still keeps the natural watercolour effect.

11. Scrubbing
This shows how the scrubbing technique creates dark edges on each stroke. Lay matching washes in each corner. Let dry. Dab dark colour on the left of the upper wash and white on the right. When dry, dampen a No. 12 shader, blot on a paper towel, then scrub back and forth towards the lower right corner on the dark dab, the white dab, and in between.

12. Using salt
This swatch shows a cool effect of simply dropping some table salt crystals in a wet wash of colour on the base tone. Make sure the paint is completely dry before scraping off the salt to leave this wonderful dappled effect.

Personal techniques

While I use traditional media for my art, I do not have a traditional approach! Here are some of the more unusual techniques that I use to give my art an edge.

Reverie

This ethereal image features several interesting techniques, including the application of salt, as described on page 31, and the more advanced technique of misting with an airbrush.

To create the smoky effect of her hair, the paper was wetted and watery black paint was dropped in along the hairline. The painting was picked up and tilted and angled to make the paint flow. Once dry, an airbrush was used to mist over the top to soften the edges, then the shapes were enhanced and exaggerated with a black hard-lead pencil.

An organic effect was achieved in this painting using the wet-on-wet technique and adding salt for texture. This gives a wonderful abstract feel to these areas, which could not be achieved with paint alone.

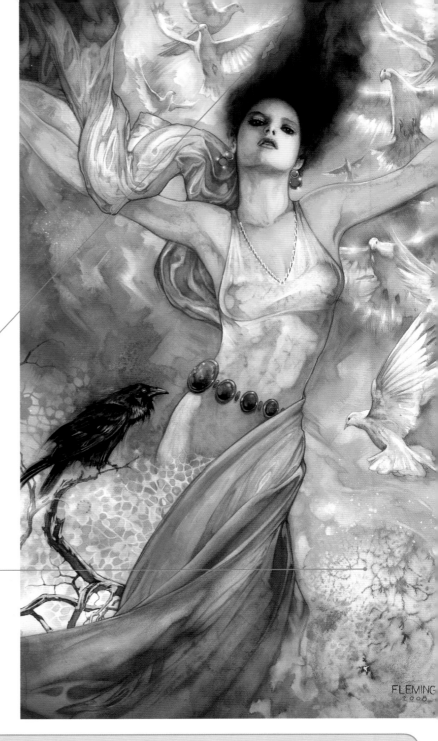

PREPARING TO PAINT: MY TECHNIQUE

When drawing a figure, my creative process begins with a thumbnail sketch to get a feel for the pose. Then, I break down the figure into parts and gather or shoot references for each element. With my references to hand, I do drawings or studies of each part on parchment (tracing) paper. When all the elements are drawn, I photocopy them, starting with the torso and the head, reducing and/or enlarging, cutting them out with an ex-acto knife and taping them together in the proper proportion. I call this process 'Frankensteining' because I am essentially transplanting body parts to form a new body.

Changes are easily made without redrawing the whole figure. If a hand looks too large, I chop it out, reduce it, cut it out and tape it back down. Finally, I make a copy of the whole figure. Sometimes I lay artist's vellum on top of the copy and redraw it to tighten it up, or I lay watercolour paper on it and transfer it via a light box. I am now ready to paint.

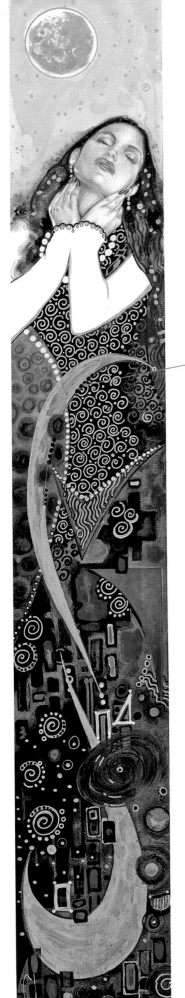

Golden Moon

This experimental piece features metallic paints, which require a different approach than watercolours. If using metallics, make sure you have turpentine to hand because they are not water-soluble.

The large graphic 'swooshes' were drawn in pencil, then painted in gold metallic paint with a small flat brush. The swirls on her dress were added with a fine-point gold paint pen. Using metallic paints is a great way to create decorative and graphic shapes, but they are very difficult to blend or achieve gradation.

Sponging

This detail from Solitude (page 39) demonstrates how to paint leaves on a tree without actually painting each individual leaf. The tree trunk shapes and background colour were painted in first as a base. To add the layers of leaves and the depth and texture, I simply took an ordinary kitchen sponge and ripped the corner off of it in a one-inch oval shape. I started with the darker leaves and dipped the sponge into some fairly thick sepia watercolour paint, but not completely saturating the sponge. With dabbing motions I applied the paint to the areas where the leaves would be. The nooks and crannies of the sponge leave behind a fantastic texture that mimics the look of leaves from a distance. I created layers of light and dark browns and green textures with the sponge that represent the feel of the leaves. Keep in mind that dark textures will recess in the painting and light textures will advance.

Venus

This painting features an advanced appliqué technique using a paper doily and an airbrush to create the soft out-of-focus effect of the central shape in the background.

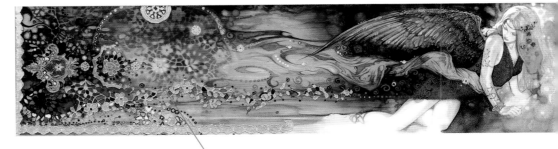

A paper doily was used as a mask on the painting and misted over with an airbrush. It was then lifted up leaving the soft pattern behind. The doily was then painted with gold paint, cut up into pieces, arranged in patterns and glued down with acid-free adhesive to echo the airbrushed shapes.

References

All artists who are working in a figurative style will need to use visual references. For fantasy art, anything is possible, so your reference images will need to cover all eventualities in terms of the things you might want to paint: from remarkable locations to interesting props, from outlandish costumes to intricate weapons. Spend time building up your reference files to give you a wealth of material to draw from.

Models

When painting fantasy females, good models are perhaps the most important source of reference you will need. It can be difficult to get professional models to sit for you, especially if you are just starting out and don't have any real credibility yet.

However, fantasy art conventions can be a great place to find willing models, and you will also find that other artists can make referrals, so networking is crucial. As your status as an artist improves and you begin to establish yourself, you may find you receive emails from models that have seen your work and want to be painted.

There are times where I see a model that fits the description of a character that I want to paint and contact her through her website, giving her a link to my website so she can see my work. More often than not they are happy to work with me. There are also specific websites that feature models that want to work with photographers and artists – one of the more popular sites is **www.modelmayhem.com**.

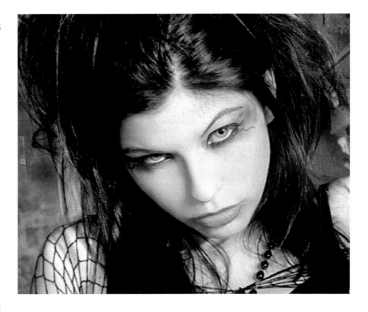

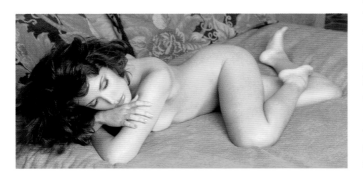

Most models love working with artists and the only compensation they ask for is the proper credit, a plug to their website and a scan of the finished image to use on their website. The models Stacy E. Walker (**www.stacyewalker.com**) and Devin Devasquez (**www.devindevasquez.com**) have been especially helpful and have provided references for many of the images featured in this book.

Most of the professional models that I have worked with have an archive of photographs that they let me choose from. Very rarely do models pose in person unless they live locally.

SHOOTING YOUR OWN REFERENCES

You don't have to be a professional photographer with top-of-the-range equipment to shoot decent references. Quick snaps taken on a compact camera are fine, provided the angle of view and the lighting are what you are after in your final image. In most cases, nobody will ever see your references other than you, so don't spend hours creating artful photographs, instead spend your time painting, which is where your true passion lies.

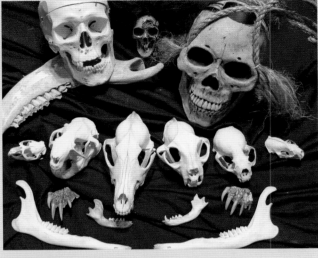

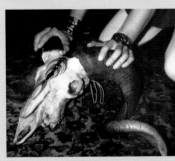

Skulls
Whether you find them macabre or not, skulls are a recurring theme in fantasy art and so, naturally, references are essential. Here I photographed the hands in position on one example from my skull collection to create a good reference to work from for the image 'Ritual' (see page 122 for full image).

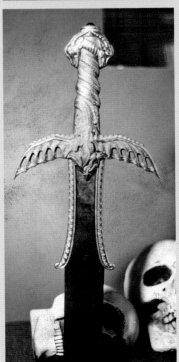

Weapons
Another common element in fantasy paintings is swords and, again, references are indispensable. If you don't fancy having a collection of your own at home (if you have young children, for example), visit shops and museums and ask if you can take photographs, or use references found on the Internet. This sword from my own collection was used as the basis of the sword in the image 'Angela' (see page 62 for full image).

Chapter 3

Building Character

There are many factors to consider when creating a fantasy picture. This chapter looks at how you can build your characters, from getting the initial idea, establishing the pose and facial expression, to understanding colour choices and lighting schemes and the creative effect these will have on your images.

Soul Harvest (detail)
Watercolour and pencil on
watercolour paper. My most
published painting to date.

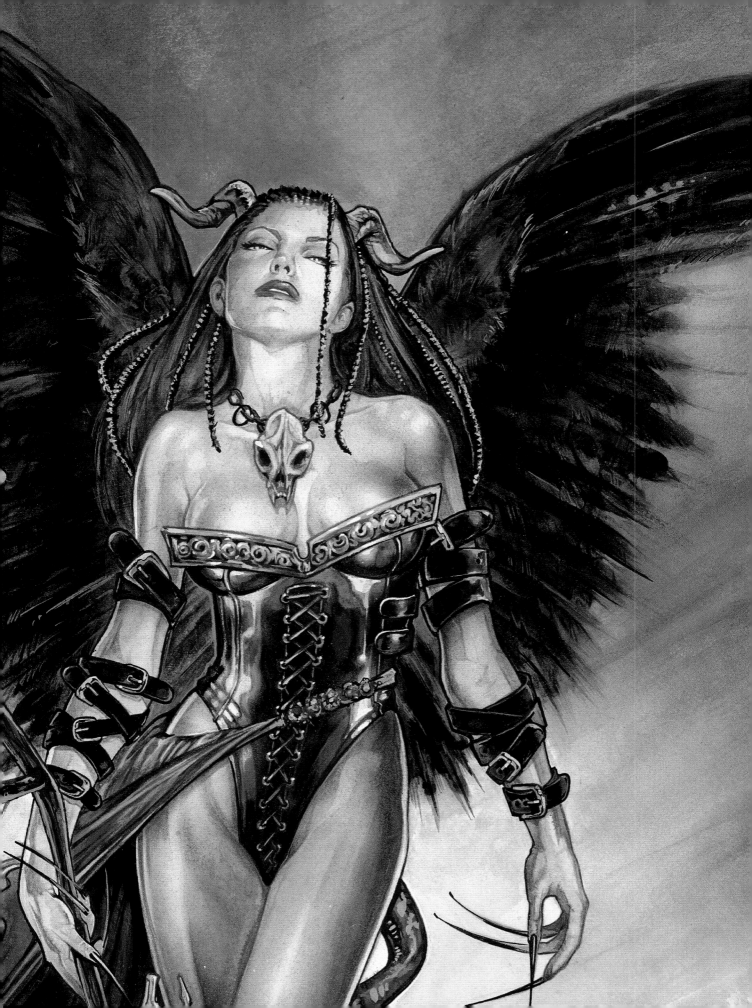

Inspiration

Inspiration is a vital part of the artistic process – without it art would simply not exist. Every artist has different things that spark their creativity. Movies, magazines and books all have inspirational effects on me, but there are two things that enthuse me like nothing else: other artists' original works and nature, the former in a technical sense and the latter in a conceptual sense.

Galleries and museums

Next time you are looking at a fantastic, historical, renowned artwork in person, get within inches of the piece (without getting reprimanded by security!) and study the brushstrokes, the layering of the paint, the composition, the lighting and colour choices that cannot be captured in catalogues or books. Observing the work of other artists 'up close and personal' always triggers something in me, and makes me want to rush home to the studio to apply my observations to my own work. By doing this you will learn a great deal about technique and discover new ways of working to produce much more exciting results.

Other artists' work can provide endless inspiration in this way – some of my biggest influences include Alphonse Mucha, Gustav Klimt, JW Waterhouse, Maxfield Parrish, Frank Frazetta, Michael Whelan, Brom, Dave DeVries and many others, depending on the style and subject that I am working on.

The natural world

Nature is the greatest inspiration for artists of all kinds. As a fantasy artist, no landscape will be more inspiring than mountains, with their rock formations, tree configurations, lakes, wildlife and, most of all, waterfalls. Water flowing over magnificent rocks inspires me beyond words – throw in an exotic bird, fish or animal and I just have to take out the brushes and paint! The key is to get out and about as much as you can and take photographs of any interesting natural locations you come across. However, if you can't do this, look in books and magazines for dramatic landscapes that you can use in your work.

Instant inspiration
As an artist you have to find ways to jump-start your creativity on demand. You can't run out to a gallery or head for the mountains every time you want to paint, so the next best thing is to rifle through art and photography books. Creating your own reference library is crucial for those moments where artist's block strikes. This is mine – I am running out of space!

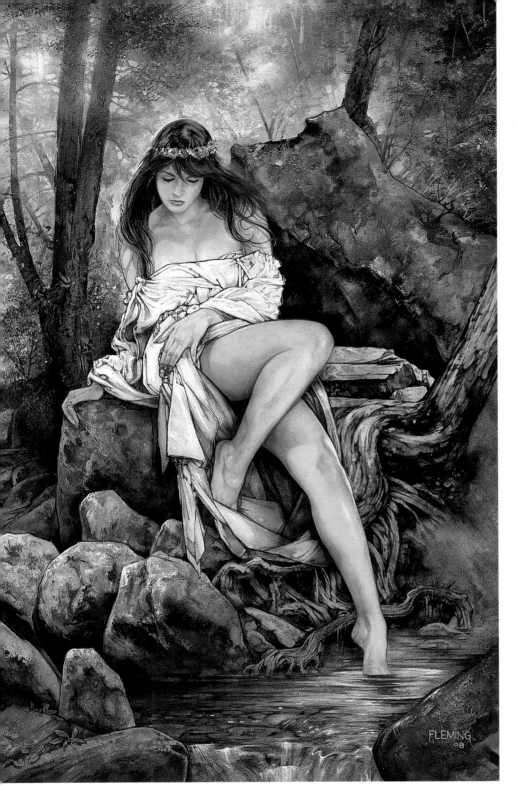

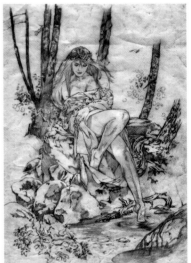

Solitude

The inspiration for this image came from a photo that was taken on one of my many camping and hiking excursions in western North Carolina. Transylvania County in NC has the highest concentration of waterfalls per square mile in the world. I received a photo of the pose from the model Devin Devasquez and knew that I wanted to use a heavily wooded area with some light penetrating the leaves as the background. I looked through my files and this photo jumped out at me immediately. Sometimes a background photo and a model photo can look like they will work together perfectly but when they are combined they don't work at all. In this case things turned out beautifully.

Pose

When drawing fantasy females it is crucial to understand how the angle of the shoulders, the angle of the hips, the tilt of the head, the curve of the spine and the flow of the legs and arms have an effect on how seductive, passive or powerful your figure is. When deciding on a pose for your figures, always think about the flow or rhythm of the body.

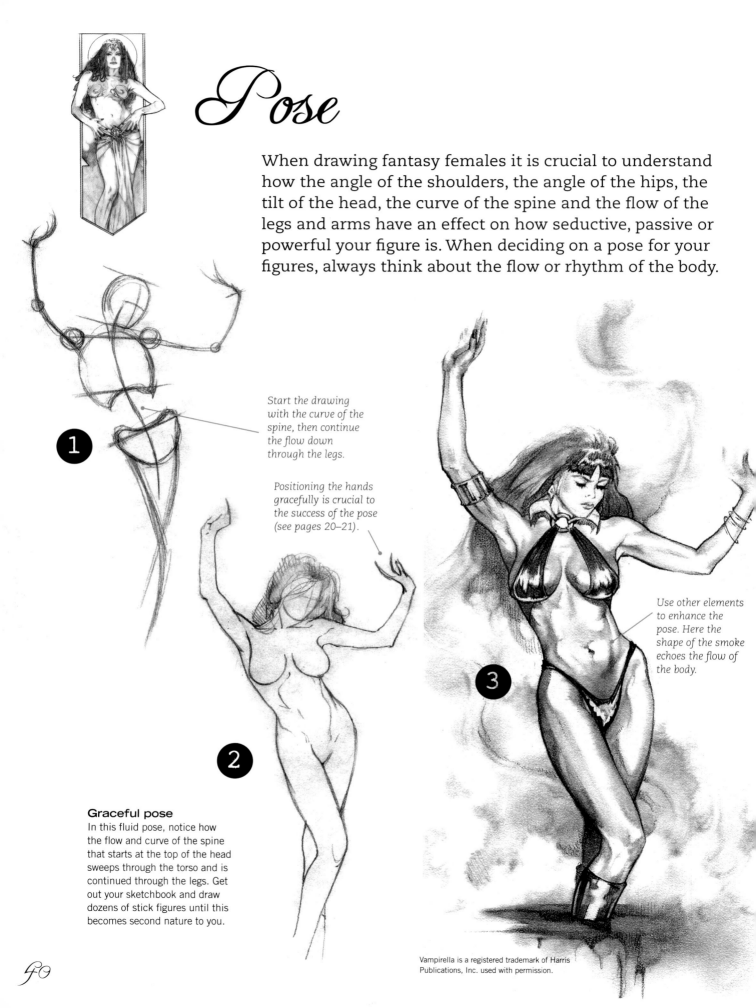

Start the drawing with the curve of the spine, then continue the flow down through the legs.

Positioning the hands gracefully is crucial to the success of the pose (see pages 20–21).

Use other elements to enhance the pose. Here the shape of the smoke echoes the flow of the body.

Graceful pose
In this fluid pose, notice how the flow and curve of the spine that starts at the top of the head sweeps through the torso and is continued through the legs. Get out your sketchbook and draw dozens of stick figures until this becomes second nature to you.

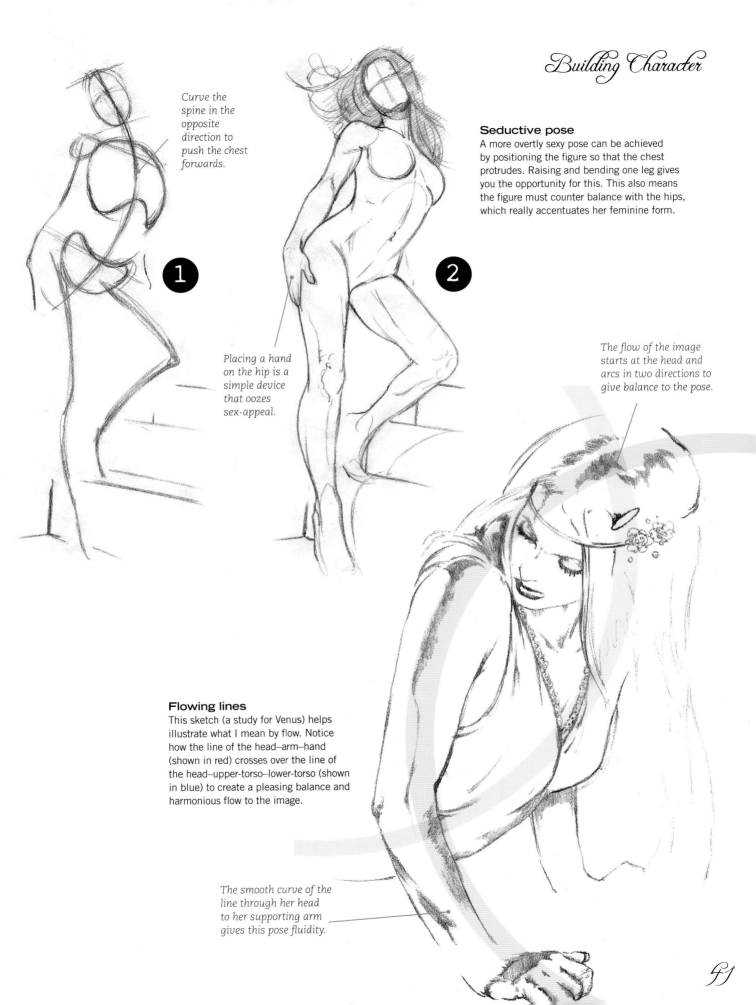

Curve the spine in the opposite direction to push the chest forwards.

1

Placing a hand on the hip is a simple device that oozes sex-appeal.

Seductive pose

A more overtly sexy pose can be achieved by positioning the figure so that the chest protrudes. Raising and bending one leg gives you the opportunity for this. This also means the figure must counter balance with the hips, which really accentuates her feminine form.

2

The flow of the image starts at the head and arcs in two directions to give balance to the pose.

Flowing lines

This sketch (a study for Venus) helps illustrate what I mean by flow. Notice how the line of the head–arm–hand (shown in red) crosses over the line of the head–upper-torso–lower-torso (shown in blue) to create a pleasing balance and harmonious flow to the image.

The smooth curve of the line through her head to her supporting arm gives this pose fluidity.

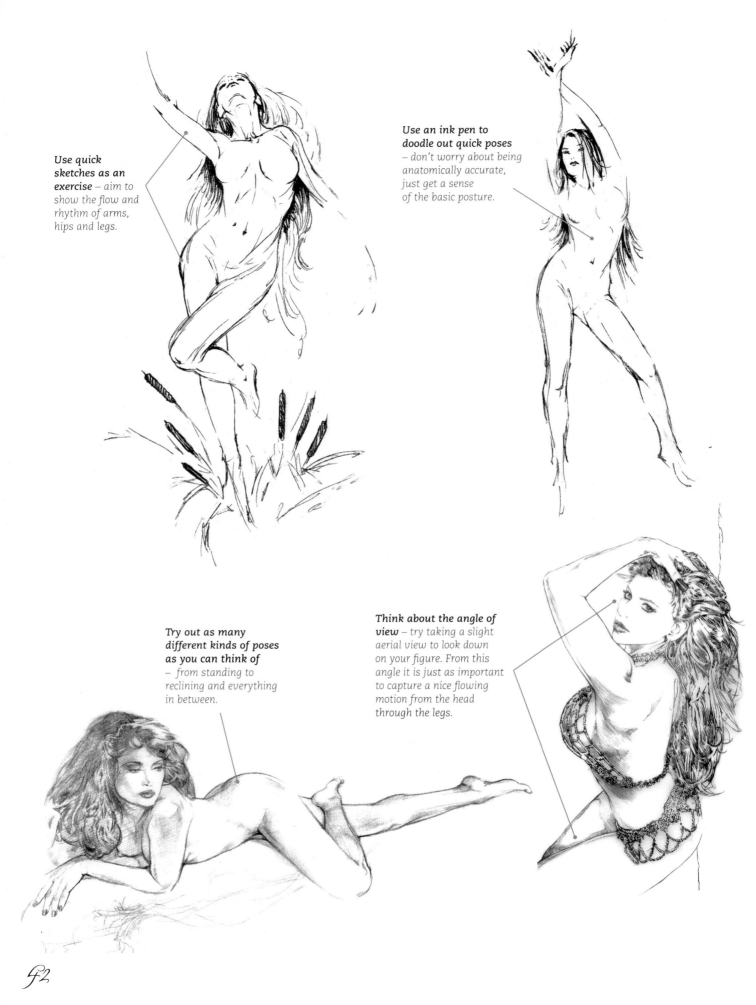

Use quick sketches as an exercise – aim to show the flow and rhythm of arms, hips and legs.

Use an ink pen to doodle out quick poses – don't worry about being anatomically accurate, just get a sense of the basic posture.

Try out as many different kinds of poses as you can think of – from standing to reclining and everything in between.

Think about the angle of view – try taking a slight aerial view to look down on your figure. From this angle it is just as important to capture a nice flowing motion from the head through the legs.

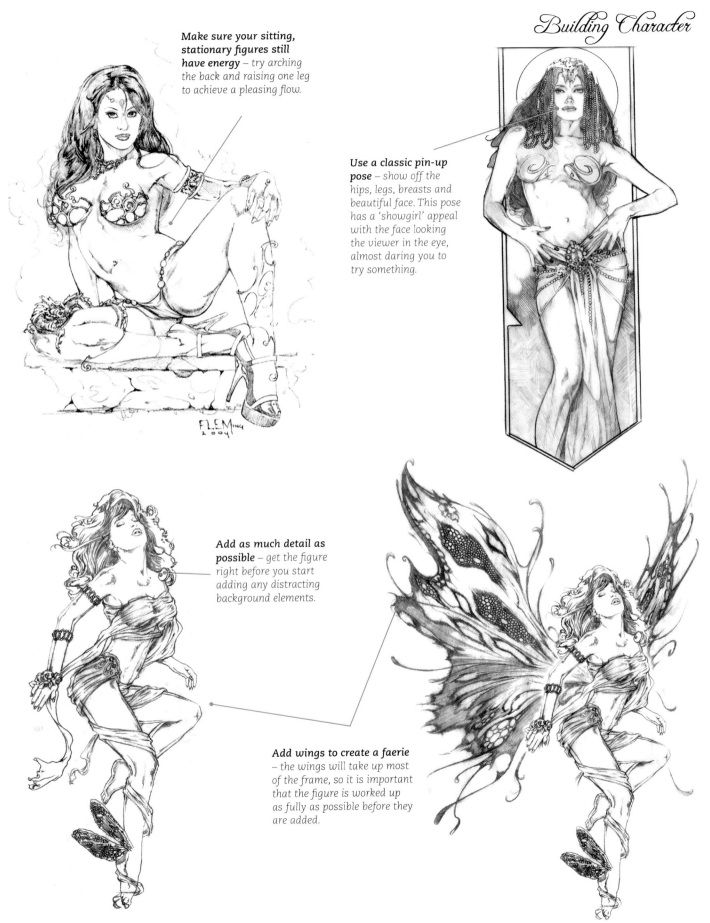

Make sure your sitting, stationary figures still have energy – try arching the back and raising one leg to achieve a pleasing flow.

Use a classic pin-up pose – show off the hips, legs, breasts and beautiful face. This pose has a 'showgirl' appeal with the face looking the viewer in the eye, almost daring you to try something.

Add as much detail as possible – get the figure right before you start adding any distracting background elements.

Add wings to create a faerie – the wings will take up most of the frame, so it is important that the figure is worked up as fully as possible before they are added.

Facial Expression

Facial expression is the most powerful tool you have at your disposal for communicating the mood and feelings of your figures to the viewer. A wide range of facial expressions need not be difficult to achieve in your images, simply by changing the style and position of the basic elements in the face.

Look into my eyes

There are several factors that have to be considered when you are trying to capture a particular attitude or mood of a character through their facial expression, but none are as important as the eyes and eyebrows. The position of the mouth also plays a valuable part, but purely by changing the angle of the eyebrows or the arrangement of the eyelids, you can dramatically change the message your figure sends out, as shown in the examples here.

Seductive
This is a straightforward face, but by simply closing the eyelids halfway, you get an alluring expression.

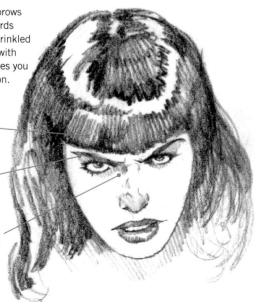

Head tilted back.

Eyes half closed.

Lips parted.

Happy
Using pleasant curves to the eyebrows along with a cheerful smile and few other lines creates a jovial expression.

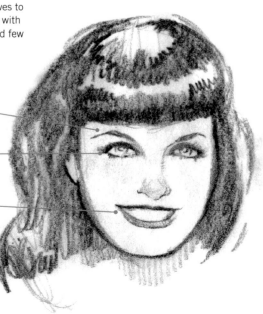

Eyebrows curved upwards.

Eyes fully open.

A broad smile narrows the lips.

Angry
Angling the eyebrows downwards towards the bridge of a crinkled nose combined with gritted teeth, gives you a stern expression.

Head tilted forwards.

Eyebrows angled inwards.

Lines around bridge of nose.

Shocked

This is quite similar to the happy face, but by crinkling the nose and opening the mouth wide, you get an alarmed or disgusted look.

Lines on forehead.

Lines around nostrils.

Mouth open to reveal tongue.

Goofy

Simply raising the eyebrows, opening the eyes wide and sticking out the tongue captures a silly mood.

More white of the eye visible.

Pronounced lines around mouth.

Tongue fully exposed.

Echidna

This face combines all the elements of an angry face with a snarled lip to exaggerate the expression even further.

The eyebrows are angled sharply downwards and the bridge of the nose is deeply furrowed to ensure her furious expression is crystal clear.

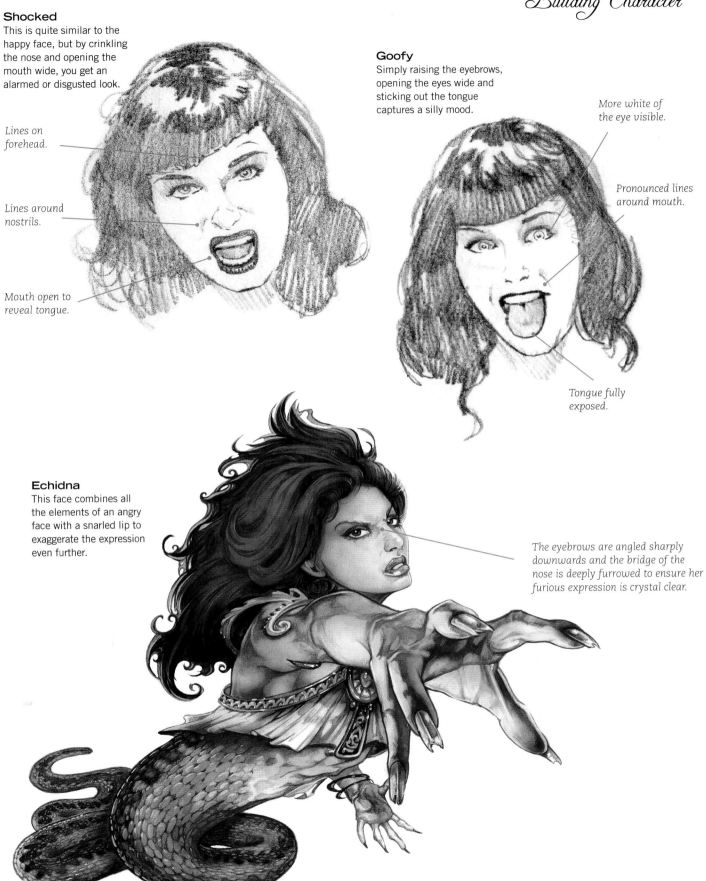

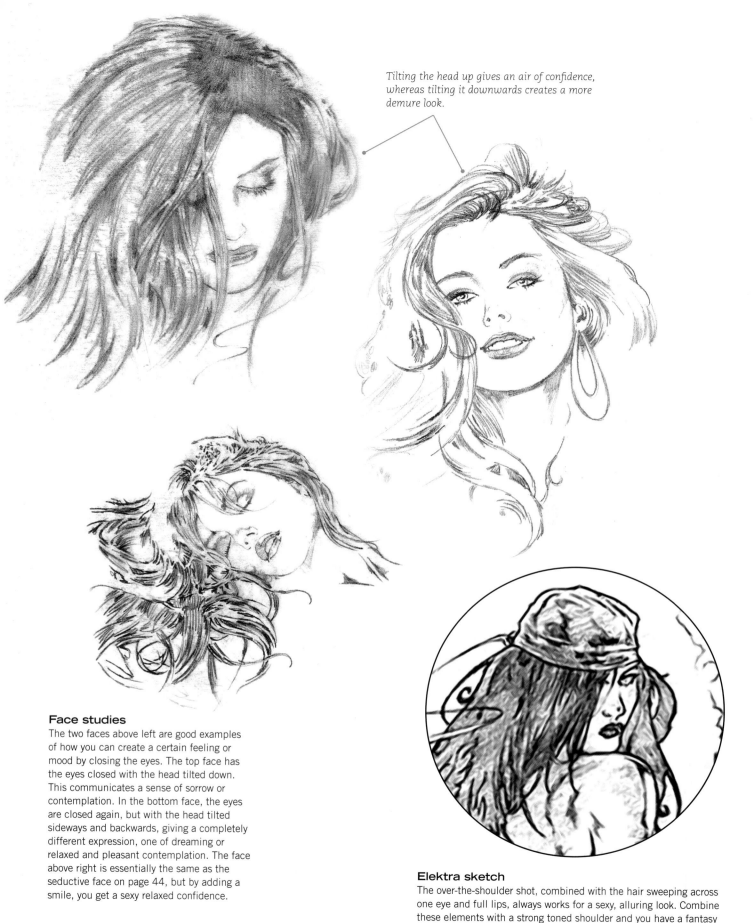

Tilting the head up gives an air of confidence, whereas tilting it downwards creates a more demure look.

Face studies

The two faces above left are good examples of how you can create a certain feeling or mood by closing the eyes. The top face has the eyes closed with the head tilted down. This communicates a sense of sorrow or contemplation. In the bottom face, the eyes are closed again, but with the head tilted sideways and backwards, giving a completely different expression, one of dreaming or relaxed and pleasant contemplation. The face above right is essentially the same as the seductive face on page 44, but by adding a smile, you get a sexy relaxed confidence.

Elektra sketch

The over-the-shoulder shot, combined with the hair sweeping across one eye and full lips, always works for a sexy, alluring look. Combine these elements with a strong toned shoulder and you have a fantasy female ready to rip your heart out.

Devin sketch

This sketch reveals how you can draw a face and leave out information, such as the left side of the jaw line. The viewer's brain then fills in the information automatically, in a process known as 'closure'. Try this out on your own face sketches and you will be surprised at how much you can get away with leaving out.

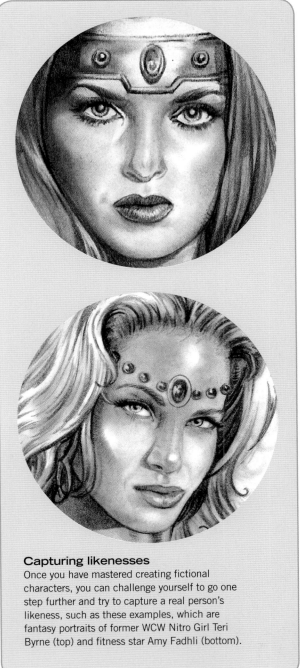

Capturing likenesses

Once you have mastered creating fictional characters, you can challenge yourself to go one step further and try to capture a real person's likeness, such as these examples, which are fantasy portraits of former WCW Nitro Girl Teri Byrne (top) and fitness star Amy Fadhli (bottom).

Seffana study

This face study (from the Sorceress step-by-step demo on page 90) demonstrates how you can tilt the head downwards so that the eyes and brow are the central focus (notice the pupils riding the top line of the eyelids), while the eyebrows are angled in a similar way to the angry face on page 44. By not crinkling the nose or gritting the teeth, it gives a serious, cold, piercing stare. I put very little detail in the nose area to avoid distraction and keep all the focus on the eyes.

Colour and Light

Two key factors to consider when planning a drawing or painting are the colour scheme and lighting. These are the first things that will strike your viewer; before they even look at the figure or the details, the overall sense of the mood or feeling of the image will come from the colour choices and effects created by the light in your piece. Think carefully about the mood you are trying to capture, whether it is aggressive, seductive, serene or playful and choose your palette and light sources accordingly.

The power of colour

Choosing the right colour scheme can be the difference between a very effective image and one that falls short. Colour plays a vital role in conveying atmosphere and meaning in a painting, and understanding how your colour choices communicate with the viewer is an important lesson you must learn.

White – *considered a cool colour, white represents innocence, grace and purity.*

Black – *the colour of authority and power, black usually has a sinister or evil edge.*

Greens – *representing nature, these colours are known to be calming and comforting. Theatres and TV/movie studios often have a 'green room' for their stars to wait in, designed to have a relaxing effect.*

Browns – *earthy, neutral and natural, shades of brown are very safe colours.*

Yellows – *cheerful, sunny and eye-catching colours. These shades are considered to be optimistic colours.*

Reds – *fiery, aggressive colours, often considered the most intense in the spectrum. It has been proved that red tones actually stimulate the heartbeat and breathing. They represent danger but also love and passion.*

Blues – *calming, peaceful and serene colours associated with air and water elements. Caution is needed with these shades as they can appear cold and depressing.*

Purples – *the colours of royalty, luxury and wealth. These shades are also considered to be romantic.*

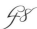

Soft lighting – *highlights are gentle and shadows are diffused.*

Hard lighting – *highlights are crisper and shadows are more pronounced.*

A slight rim light on the abdominal and outer thigh areas brings out the musculature.

FLEMiNG

FLEMiNG 2000

Lighting effects

When it comes to capturing a mood, lighting is probably the most important factor to consider. Do you want an evenly lit, low-contrast feel, or a shadowy, moody, dark atmosphere? The way a figure is lit dramatically changes the visual effect. You can take the exact same face and pose, light them differently, and the result can seem like a completely different character.

The most basic of lighting schemes is top lighting, which is similar to the way sunlight hits us, or overhead lighting indoors. Sidelighting can be dramatic and create a sense of mystery. Under-lighting is one of the most dramatic ways to light a figure and creates a sinister, evil feeling often used in horror subjects. Lighting is such a complicated subject that whole books have been dedicated to it, but the key is to try out different light sources, intensities and directions for yourself to see the effects they have on your images.

Butterfly Maiden and Bat Maiden
These two images perfectly illustrate how lighting can be used to show Good Vs Evil. I used the same model and pose on both images. I drew the Butterfly Maiden first, then I flipped the image and substituted the light whimsical butterfly imagery with dark and gothic characteristics. I replaced the blonde hair with dark hair, used bat-like wings instead of butterfly wings, swapped the butterflies for bats, and so on. I thought that it would also be more effective if I darkened the skin tone on the Bat Maiden. So, without the luxury of colour, you can still effectively change the mood or feel of your piece utilizing lighting, symbolism and skin tones alone.

Skin tones

One of the most important colour choices when painting fantasy females is the skin tone you choose to give them. From warm, inviting flesh to cool, 'otherwordly' skin, there is a wide variety of different effects that can be achieved through colour and shading alone.

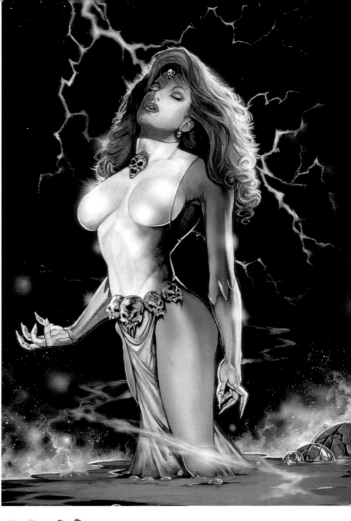

Angela (detail)
I wanted Angela to stand out from the background, so I used mostly warm colours with an orange hue to them. Initially there was too much contrast between the warm flesh tones and the cool blue colour of the background and it didn't look like the character fitted in with the environment, so I added some cool tones subtly to the skin to restore the balance.

Mystique
This mutant fantasy female from the Marvel X-Men comics is characterized by her blue skin. In my depiction of her, I used no warm secondary tones in her skin at all, and contrasted these icy tones with hot red hair and cherry red lips to create a striking image.

Elektra (detail)
Sometimes you have to consider the culture or ethnicity that a character comes from. Elektra is an exotic Greek ninja, so it was appropriate to give her a darker olive complexion that is common to Mediterranean people.

Elektra (detail)
The skin tones in this piece were chosen based on the theme of the story entitled 'Fever'. The goal was to achieve a sick, viral feeling of nausea. The bluish tones work well to give the feeling of the character breaking into a cold, sickening sweat.

Depths of Love (detail)

The challenge here was to create a submerged, underwater effect. I used pencil to create all the skin tones, then added a touch of blue to give a cold, watery feel. The lighter shades of the skin contrast well with the bold colours in the rest of the painting, drawing the eye to the figures and communicating a very fantastical feel.

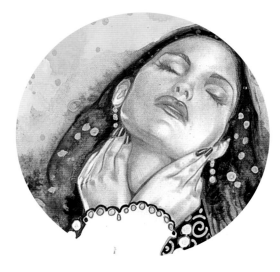

Golden Moon (detail)

The aim here was to contrast the skin tones with the rest of the painting, so I rendered the skin tones in pencil and painted the rest in colour. The pencil tones draw the eye to the skin, even though it is absent of colour.

Ring of the Minotaur (detail)

The skin tones here are treated as I would in a black-and-white drawing, but using a limited palette of yellows and browns. This makes the face harmonious with the background tones.

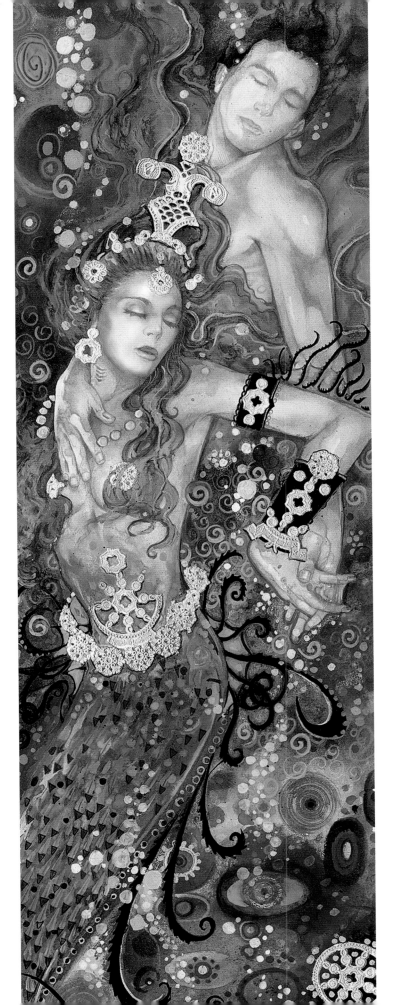

Chapter 4

Hair and Costume

A woman's hair is her crowning glory
and so is a vital aspect in rendering
your fantasy females. Clothes and
accessories also make a big statement
in a piece. This chapter focuses on
how to draw and paint flowing cloth
and other fantasy clothing, and
reveals how you can use hair, make-
up, jewellery, armour and weapons to
add to the impact of your images.

Ezra (detail)
This image was created
for the cover for a limited
edition Ezra comic published
by Arcana Studios.

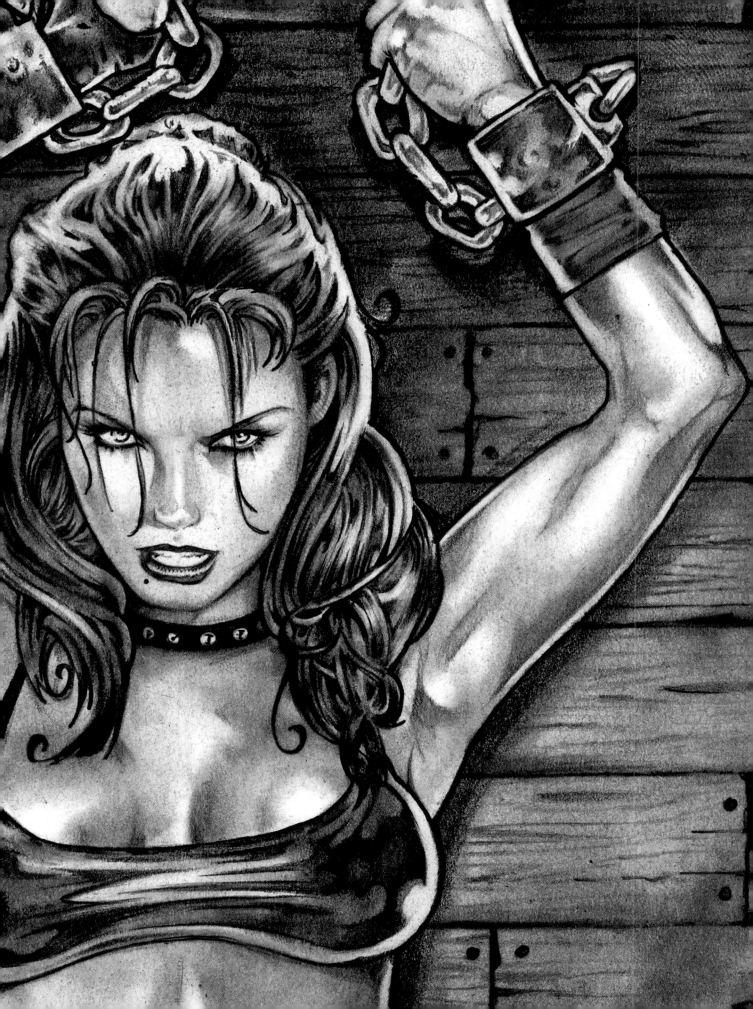

Cloth and Drapery

One of my favourite things to draw and paint is flowing cloth – I prefer to drape my figures in cloth than dress them in traditional clothes. It is a fantastic design element – it can flow in any shape and size, which makes it a dramatic compositional tool. Use its folds and swathes to lead the eye to the focal point of the image, or away.

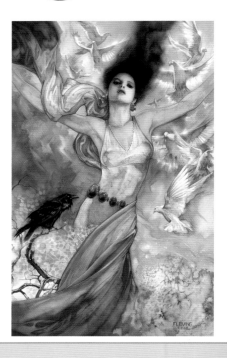

How to approach cloth

The key to drawing and painting realistic cloth is shooting photo references. Lay out different types of fabrics in various formations, wrap them around things and people and shoot away. Being able to see the actual folds and movements of the cloth in photos is invaluable when trying to recreate effective lifelike forms. Follow this quick four-step lesson to discover how to drape your figures in cloth effectively.

RENDERING CLOTH

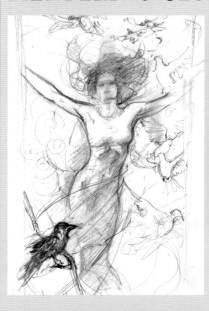

Step 1: Make an initial sketch
In the initial sketch of the figure, draw in simple motion lines to represent the cloth. The aim is just to get a feel for how the cloth will flow in the composition and be used as a design element.

Step 2: Take photo reference
When you have decided how you want the cloth to fall around the figure, shoot a photo reference. If you don't have a model to wrap the cloth around, use an object to simulate a human torso such as a barstool. Don't worry about the cloth colour; the important thing is to capture the details of the folds that you want to recreate in paint.

Step 3: Make a study
Using the photo reference, sketch out studies of the cloth on parchment (tracing) paper or vellum. Pay close attention to the shadows in the creases and the details of the folds. It is important to render correctly the edge of the cloth where it actually wraps around the figure.

Autumn

This image is a perfect example of how cloth can be used as an effective vehicle in designing a composition. In this Art Nouveau-style drawing there are lots of details that could potentially distract from the main focus of the piece – the figure. I used the flowing cloth in the image to lead the eye around and back into the figure to keep the focus where it should be. Notice how the flow of the cloth always leads back into the subject whether it is sweeping, dropping or wrapping around the figure.

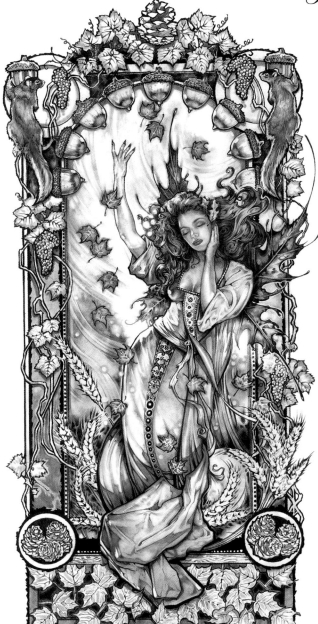

Step 4: Final painting

Use the studies to guide you in the final painting. Smooth flowing folds are extremely important when rendering cloth. Each fold and crease has its own shadow, medium tones and highlight. If you want to draw the eye away from a certain area, knock down the highlight and use more medium tones.

Eve

We have seen how cloth can be used as a design element, but it can also carry symbolism. I wanted to include the concept of the serpent in this piece along with the apple and the figure, but I did not want a literal depiction because I was keen to keep a soft, feminine feel to the painting. Working with the long, thin format, I used the green snaking cloth to suggest the presence of the serpent instead of an exact representation of it.

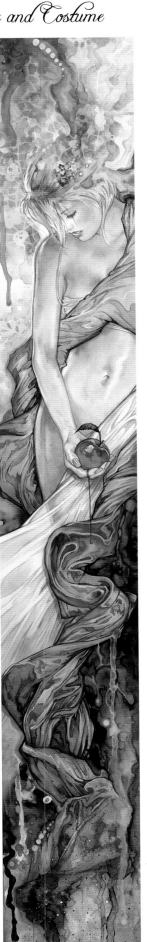

Fantasy Clothing

When it comes to clothing your female figures, the alternatives to flowing cloth are super-tight, form-fitting and high-shine materials such as latex, PVC, spandex and Lycra. When drawing superheroes and comic book characters in particular, it is essential to learn how to draw and paint these materials.

Essential techniques

The way to approach figure-hugging materials is to think of them simply as coloured flesh. Draw or paint the figure as though you were painting a nude, then add details and accents of wrinkles at the joints or points of movement – such as the waist, crotch, elbows and knees – to suggest the fabric stretching around the form.

Contrast is the key to creating the reflective quality of these skintight materials and of other, decorative details, such as studs or buckles on leather. In order to make something look shiny there must be areas of very dark shapes juxtaposed with bright white highlights, as shown in the following examples.

RENDERING TIGHT SHINY CLOTHING

Leather and studs
Skintight leather studded trousers are a great fantasy wardrobe choice and are rendered as follows:
Step 1: Apply very dark shading right up against the legs, as if the trousers are not actually there.
Step 2: Create the studs using a click eraser in a circular motion to lift the pencil off the page, leaving a white dot.
Step 3: Take a fine blending stump and add a 'U' shape to the bottom of the dot, letting it fade out gradually.
Step 4: Take a darker pencil and make a dark curved shape on one side of the blended tone. This will give you a shadow and leave you with a 3D-effect stud.

Shiny stretchy fabric
Create the effect of a PVC bra stretching in four simple steps:
Step 1: Draw in the basic outline then, with medium pencils and blending stumps, lay in a medium tone leaving the outside edge as a white highlight.
Step 2: Take your dark pencils and make swirling shapes on the main part of the breasts to contrast with the highlights.
Step 3: With a click eraser, make crisp white lines in a 'Z' shape in the area between the breasts.
Step 4: Take a sharp darker pencil and outline the highlights, which will enhance the contrast with the whites and create the shiny look.

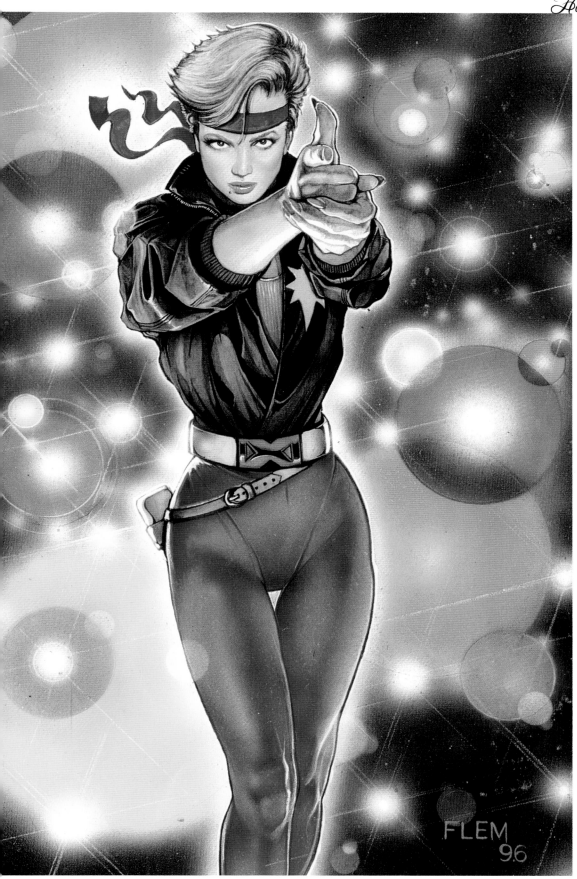

FLEM
96

Dazzler
When designing a costume, research is usually necessary, whether it is a past or present fashion style. This character was popular in the 1980s, hence the Olivia Newton John haircut with a headband, and the Pat Benatar-style outfit. The leather jacket with different-coloured tank top underneath was a popular look. Combine this with form-fitting spandex pants, made popular by the hair-metal bands, and you have one hot 80s chick!

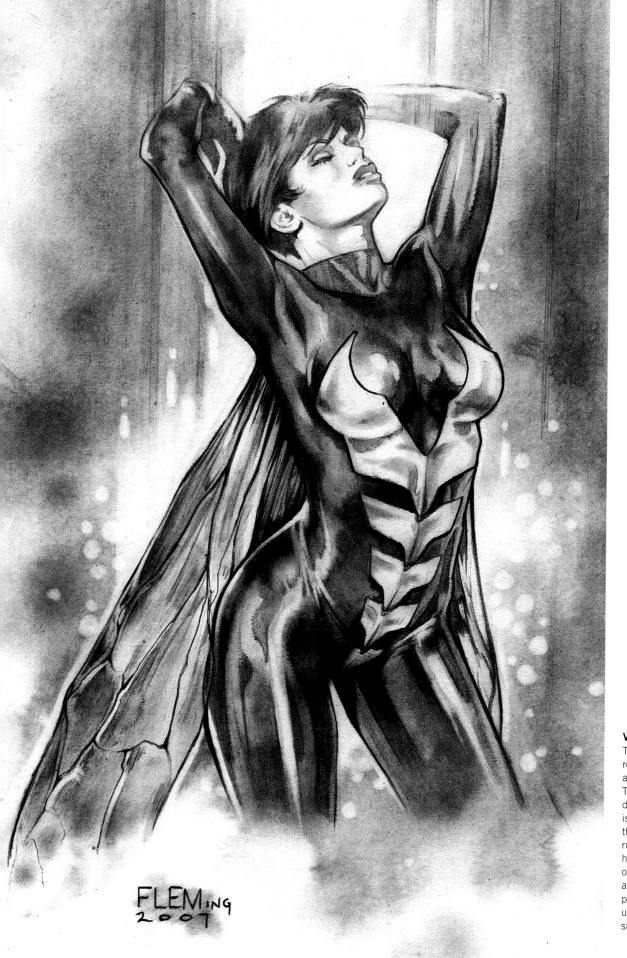

FLEMing
2007

Wasp

This costume was rendered essentially as black shiny skin. The only way you can discern that it is fabric is by the neckline on the suit. As a general rule, the brightest highlights on a shiny object should always be applied on the highest point of the form, unless there is a strong sidelight or rim light.

USING EVERYDAY CLOTHING AND OBJECTS FOR REFERENCES

When creating clothing and props for your figures, you don't need to have a wardrobe full of outlandish clothing and weapons in order to succeed. Everyday objects and articles can be used as references, which can then be turned into fantasy items in your final image.

- Washing-up gloves are favourite and highly effective items. Use yellow gloves as they are fairly neutral and show nice details in terms of folds and wrinkles. You can change the colour of the gloves in the painting to any colour that works for the character, as long as the lighting and form is right in the reference photo.
- Bed sheets are fantastic for capes and cloaks. Keep different-sized sheets in black and in white in your closet. Just tie or pin a sheet around your subject's neck and you have an instant cape.
- Hooded bathrobes (or hooded tops or sweatshirts combined with a sheet) are superb for hooded characters such as witches or sorceresses.
- Broomsticks or mop handles are great for staffs, wands and spears.

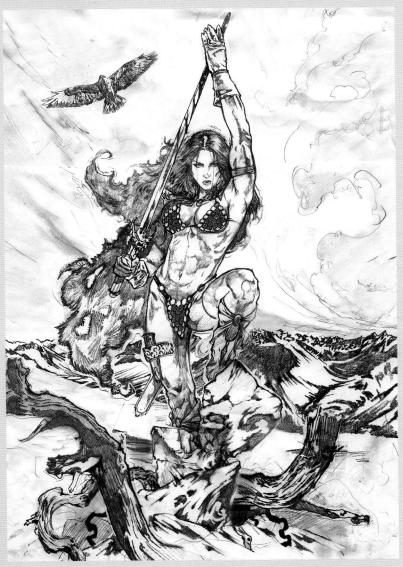

Warrior Queen
Have some fun creating costumes for your figures using any items that come to hand, then let your imagination turn them into exciting and original fantasy costumes. Ordinary yellow rubber gloves became leather gauntlet gloves for this dramatic sword-bearing warrior queen.

Hair and Make-Up

Unlike physique and facial features, people have the ability to style their hair any way they like. They can also disguise certain features and enhance others with make-up. The way a person chooses to wear their hair and make-up reflects on their personality. When creating a fantasy female you must consider what kind of attitude you want them to project and then render the hair and make-up to match.

How to approach hair

Whether you decide to draw or paint a head of long, short, wild, slicked back, curly, straight, blonde, auburn or brunette hair on your fantasy female, always treat the hair the same way: as a single, solid shape first, then add details to show the flow and texture.

The most effective way to render hair is to lay in the basic shape with a medium tone, whether it is colour or black and white, then go back with pencils and draw in the lines and direction of flow. Once these lines are in place, you can then add shadows and highlights to create the volume and depth of the mass.

Hair is similar to cloth (see pages 54–55) in that it can flow, wave or hang in any direction, which makes it a perfect design element and compositional tool.

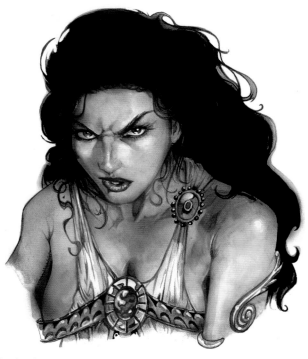

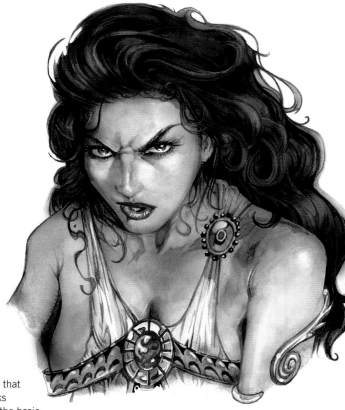

A single mass
These images illustrate perfectly how hair needs to be approached. You can see that when all the detail is eliminated from the hair (above), the solid shape still works effectively, and there is no need to draw each individual strand. Once you have the basic shape that works in your composition, you can then add details to show the flow and movement of the hair using coloured pencils (right).

The effect of make-up

Aside from the general skin tone (see pages 50–51), the thickness of the eyelashes and the colour of the lips are both factors that can change the look and attitude of your character dramatically. Luscious red lips will emanate sexuality, while paler lips can give a more earthy or natural look. The darkness of the eyelashes and eyelids also changes the personality of the character. Light, sparkly eyes give the viewer a feeling of innocence, while darker eyes can project a sense of power or menace.

A make-up artist uses lipliner pencil and lipgloss to emphasize the shape of the mouth. Mimic this with a coloured pencil to add a dark outline then shade leaving points of shiny-looking highlight.

Women have been using black kohl pencil for centuries to give them smoky, sultry eyes. Use a soft pencil and blending stump to create the same effect.

White Queen (detail)
In reality, good make-up should not be immediately apparent, but a flawless finish to the face is almost always the result of a good foundation! In art, we can dispense with having to cover up pigment irregularities and spots, as these are not present in the first place, but it is still important to create smooth skin tones. I often use an airbrush to smooth out and blend the skin tones and to eliminate any irregularities that could be mistaken for skin blemishes.

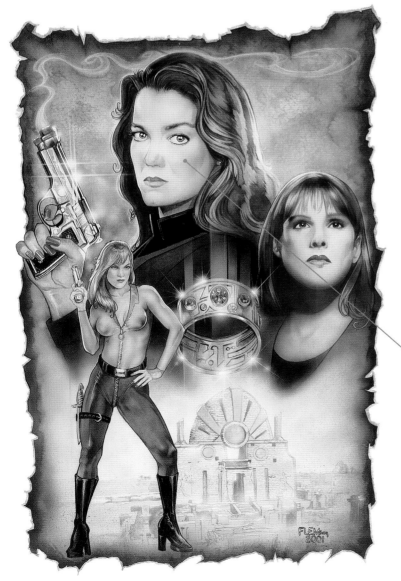

Use some pink to add a healthy glow and to emphasize the cheekbones, in the same way that a make-up artist would use blusher.

Ring of the Minotaur
When painting real people, as here, it is important to capture their positive features while eliminating or minimizing the less attractive features. Sometimes this entails making the eyelashes a bit longer or darker, the lips more colourful, eliminating blemishes and smoothing out the skin tones.

Jewellery, Armour and Weapons

What would a princess be without jewellery or a warrior without a sword? When creating fantasy characters, the size, shape, design and type of weapons and jewellery can make or break the visual impact of the piece. Jewellery is a great design element because you can draw it in any shape or size, and use it as a way to break up boring areas, adding colour and sparkle.

Angela
This warrior princess is characterized by her elaborate armour and weapons. Use the shapes of armour to enhance the silhouette of the character, with spikes at the shoulders and knees, and take the opportunity to add extra weaponry to the armour, such as the menacing blades on the underside of her armbands.

Less is more

When it comes to adding armour to your female figures, my advice would be to go sparingly. The armour should be more implied than anything, as if you cover up her entire body with a thick suit of armour she will no longer have the necessary 'fantasy' appeal. Depending on the character, metal-plated bras, wrist and shin protectors, and supplementary items such as shields are probably all that are required.

Similarly, when it comes to jewellery, use it to help emphasize the flow of your image and to add detail to areas that are lacking, but make sure it does not steal the focus from your figure's face and body. For example, a simple 'choker' band around the neck will draw the viewer's eye up to the face, whereas an elaborate dangling necklace will probably just distract.

Elektra
Always choose a weapon that fits the character's personality and cultural background. Elektra is a highly trained ninja so she uses martial arts weaponry. This dramatic image shows the assassin using her best-known weapons: sai swords.

DRAWING AND PAINTING CHROME METAL

As with the shiny materials discussed on pages 56–58, the reflective quality of chrome metal again requires there to be drastic changes in value between the darker tones and the highlights.

The most common way to depict chrome is using light blue for the medium tones and browns for the shadow areas. The reason for this is that, years ago, when automobile manufacturers photographed their cars, they shot them in the desert to avoid distracting reflections. The result was the blue colour from the sky reflecting on the top side, with the under side reflecting the browns of the sand. This worked so well that it has become an iconic way to paint metal.

Whether drawing or painting, approach rendering metal in the same way:

- The outer edge should be the brightest highlight.
- Decide where your shadows are and lay in a medium tone to define the shape.
- Take a very dark, fine pencil or brush (or even a fine marker) and with squiggly crisp lines, outline the medium shadow tone.
- Add a very light graduated tone from the opposite side of the form and let it get lighter as you approach the shadow area with the outlines.
- Finally, add the super white highlights around the edges with opaque white paint or using an eraser.
- To make the chrome sparkle, put a pure white dot on the edge of the shape, then take a very sharp, white pencil and make sunburst marks radiating outwards.

Cybergirl
When working with pencils, the key to successfully depicting metal is all down to shading. Study how I have placed the highlights and shadows with hard-edged contrast to suggest the highly reflective surface and try it for yourself on your own images.

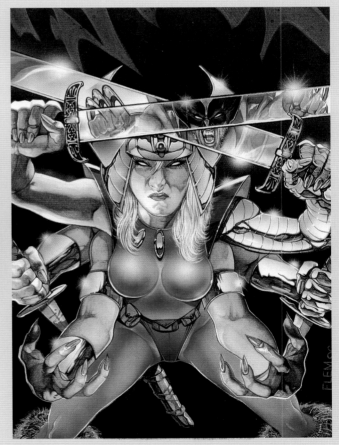

Spiral
Reflective metal can be used to show off-screen characters, such as the aggressor this character is defending herself against, adding a story-telling element. Notice the sunburst sparkle effects and how these help to suggest the glare of bright light hitting the chrome surfaces.

Chapter 5
Female Cast

From a super-sexy space heroine to
a neo-classical goddess, this chapter
contains five in-depth step-by-step
demonstrations – using basic media
and simple techniques – to show
you how to create a host of different
fantasy female archetypes. A gallery
featuring some of my best work
follows the demos, to inspire, enthuse
and delight you.

Sorceress (detail)
Half the work is done for
you when you have a model
as great as Seffana!

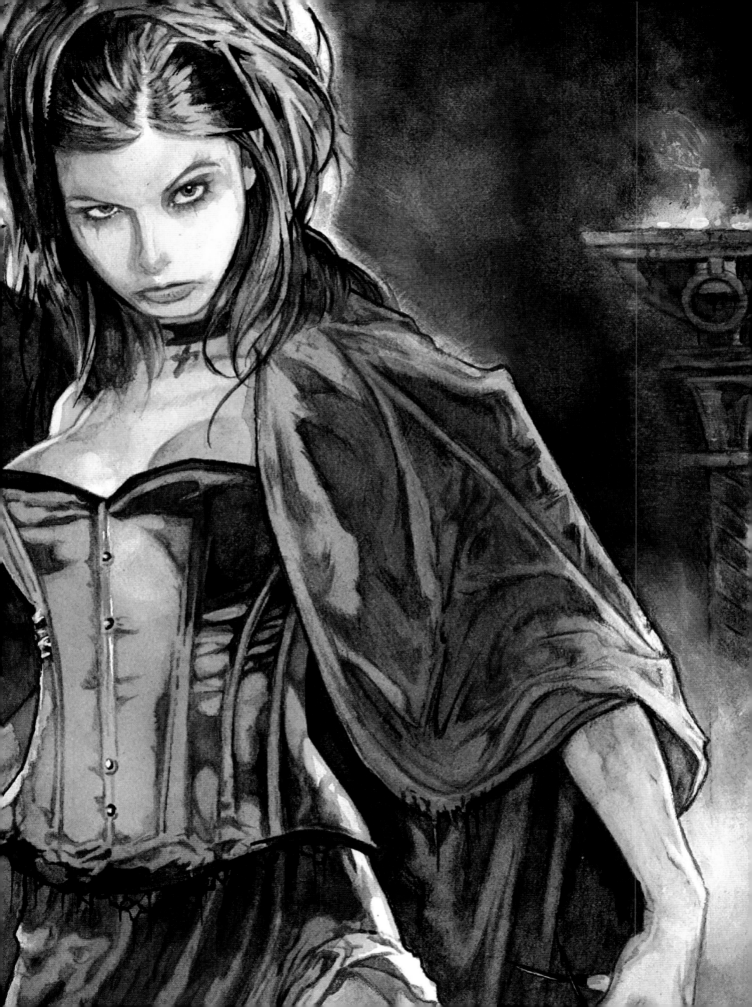

Heroine

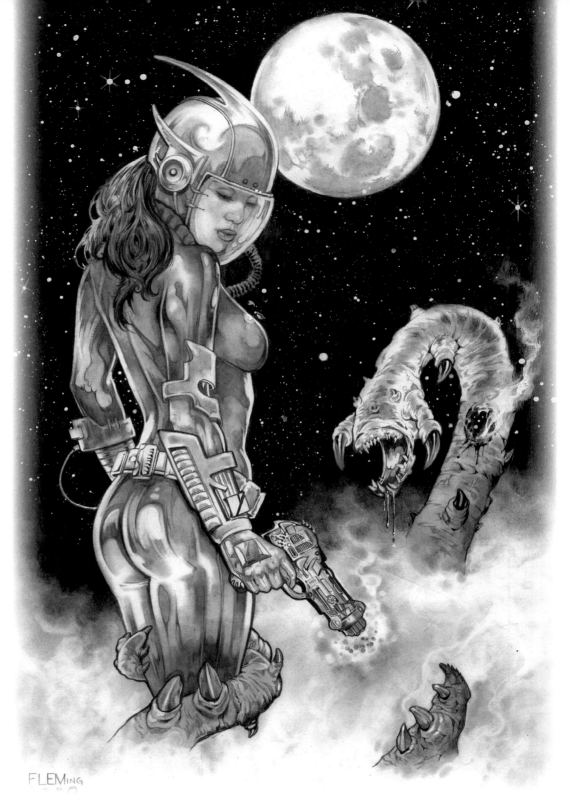

FLEMing

A sexy cyber chick, tooled-up with a laser gun, makes a great fantasy heroine. There may be no atmosphere in space, but there certainly is in this image with its dramatic starlit background. This demonstration uses pencils of varying hardness and just a touch of opaque white watercolour to reveal how you can draw your own sci-fi heroine for the rest of the universe to admire.

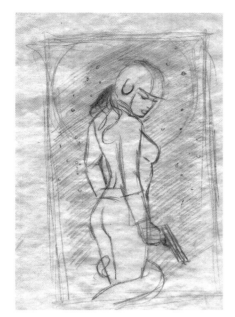

Step 1

Sketch out a thumbnail

Plot out the image in a rough thumbnail sketch. The character design here is a 'cool-as-a-cucumber' sci-fi heroine, unflustered by an alien trying to attack her. The key things to lay down at this stage are an impression of her costume – something sleek and figure hugging with a helmet – and the background element of the moon to set the figure in an outer-space context.

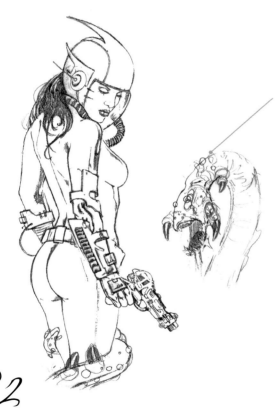

Don't get too bogged down in fine points – just get a general feel for the details you want to add later.

Step 2

Develop the sketch

When you are satisfied with your thumbnail, create a new pencil sketch to add more information and develop the costume. Her helmet needs more interest, so draw in some pointed shapes and oxygen tubes to enhance it. Add some initial ideas for details on her gun, belt and armband to get a sense of their technical nature. The tentacle is not dramatic enough on its own, so add the alien's head in front of the heroine for extra impact.

Step 3

Transfer to final media

When you have completed the rough sketch, transfer the line drawing to smooth surface Bristol paper using a light box. Use a circle template to plot in the moon. There is practically no shading at this stage, but do fill in some black areas such as the ear plate on the helmet, details on the gun and some shading in the creature's mouth.

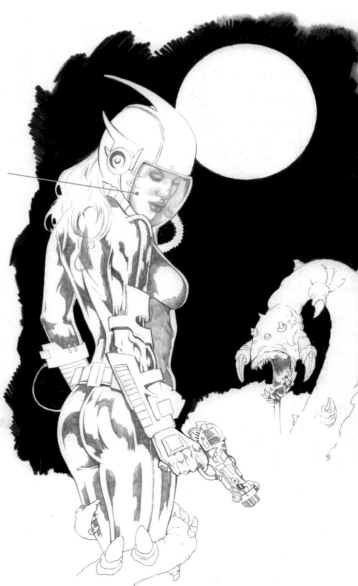

Step 4

Block in the background

Now start the rendering. This image is going to have a deep space background and a wonderful sidereal feel, so it is a good idea to lay in the background that the figures will work against early on in the process. With a super dark background the figures will start to jump off the page.

Use an 8B pencil with a decent amount of pressure to get a very dark effect.

Render the softer tones in the face using an HB pencil and a very small blending stump.

Eliminate the pencil strokes using a large blending stump, rubbing really hard until you get a smooth tone.

Step 5

Start to shade the costume and face

Lay in some of the darker details and areas in the costume. Using an HB or 2B pencil, define some of the important areas that bring out the anatomy, such as the shadow areas under her arms, and her stomach, elbows and legs. You are aiming for a shiny feel to the costume, so you will need to have dark graphic shapes next to very light highlights to get the reflective effect (see Artist's tip, page 70).

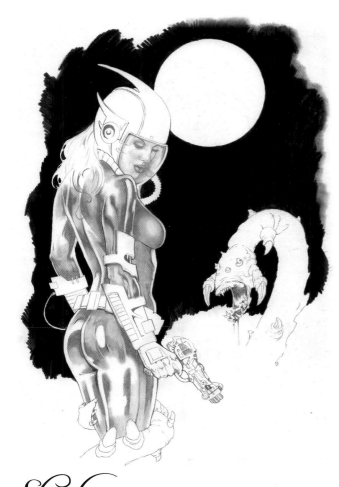

When the darker tones are laid in over the mediums the costume starts to come alive.

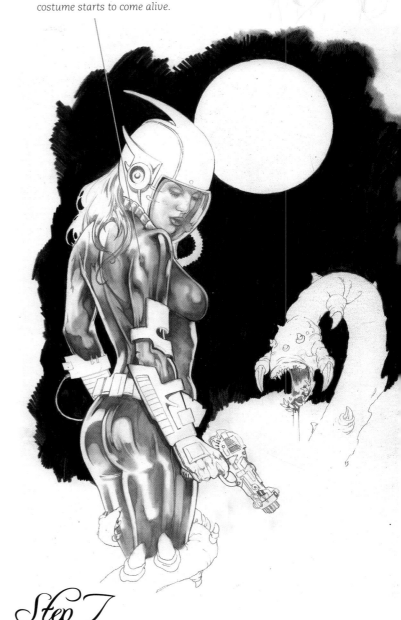

Step 6

Blend the tones

Take a medium blending stump and soften the outer edges of the dark graphic shapes that you laid in during Step 5. Blend all the medium tones around the darker areas, but be careful to leave the highlighted areas white.

ARTIST'S TIP

If you blend into areas that are meant to be highlights, use a kneaded eraser to rub the whites back out. For smaller areas, or harder-edged whites, use a click eraser (one that looks like a pen), which will allow you to apply more pressure. The benefit of using a smooth surface paper is that pencil can be lifted up quite easily.

Step 7

Darken the shadows and details

Once the medium tones are blended in, take a 2B or 4B pencil and darken the shadow areas and details on the costume that were lightened in Step 6. When you want an element of your drawing to 'pop', putting a dark shadow or tone next to it will create contrast that will cause the lighter area to come forwards. Notice how this works on her armbands, gloves and belt.

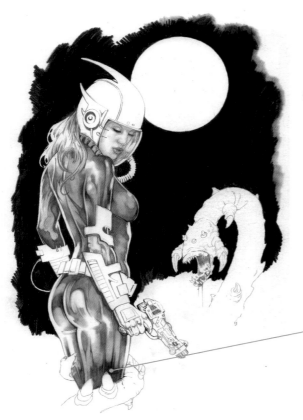

Step 8

Adjust the contrast and add more detail

Take a slightly darker pencil, such as a 4B or 6B, and darken the areas that will pop other elements, such as the bottom of her thigh where it meets the creature's tentacle, details on her collar, eyelashes and so on. Darken the edge of her shoulder so that her face stands out more. Start adding detail to the hair. Add lines with an HB pencil to indicate the flow of the hair, then use a blending stump to shade a medium tone in the direction the hair falls.

Darken this area to provide contrast with the alien's tentacle.

When rendering her helmet, add a little swirl to the shading for interest.

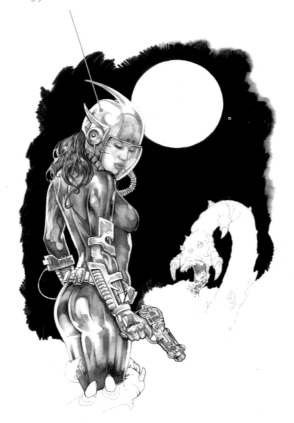

Step 9

Add detail to the costume and hair

Start adding details and shading to the mechanical parts of her costume, such as the helmet, armbands, gloves and gun using a .03 mechanical pencil. Start by lightly shading the outlines and shapes that define the forms, such as the knuckles, details in the gun and armband. Use a small blending stump to soften the shapes and bring out the form, keeping in mind where the highlights will be. Then use a 2B pencil and a medium blending stump to really darken and render the hair.

ARTIST'S TIP

When rendering objects with a metallic surface, such as the upper armband and belt in this image, take a blending stump with some residual graphite on it from previous usage and smudge the inside of the shape leaving the outside as the highlight. Then take a mechanical pencil and add little dark, hard shapes and lines around the corner areas, which will really help create the high-chrome feel. Notice almost all the metallic elements are left white around the edges.

Step 10

Extend the black and render the alien

Continue the pure black to the page border. With a smooth background, you will notice areas that need work, such as the bottom right-hand corner, where an extra tentacle protruding from the smoke will add interest. Use a medium blending stump to shade the sides of the horny shapes on the alien leaving a line of white highlight down the middle and at the edges. Take an 8B pencil and darken in an oval shape in the middle of the creature. Smudge the edges with a blending stump, getting lighter as you move away from the hole to create the effect of scorched flesh. Paint some pieces of dangling flesh with a fine brush and opaque white watercolour.

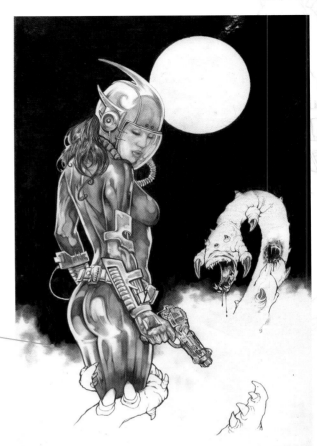

Use a large blending stump to soften the edges of the smoke, giving a sense of its swirling motion. Make the edges very irregular, as smoke does not move symmetrically.

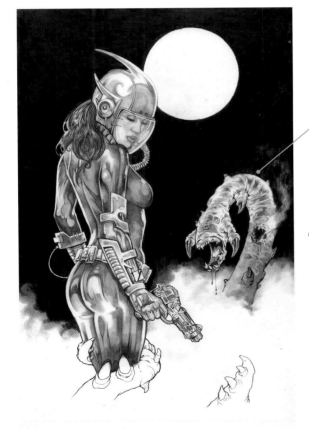

You don't want the alien to compete with the figure in the foreground, so don't add too much sharp detail to it.

Step 11

Detail the alien and blend the smoke

Take a small blending stump and, using the residual graphite on it, create ring-like shapes around the length of the alien. Add creases and other details with an HB pencil. Make the creature's body darker and less detailed as it meets the smoke line. Take a large blending stump or a soft cloth wrapped around your finger and lightly swirl it around in the smoke until you get the desired motion. Then go back and lighten areas and create paler swirls by doing the same thing with a kneaded eraser.

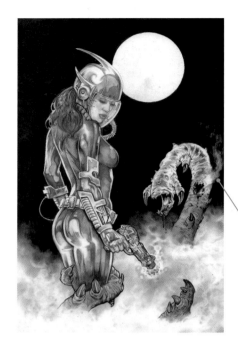

Step 12

Extend the smoke and render the tentacles

Continue the smoke to the bottom of the page. The kneaded eraser is crucial for this: the smoke effect is achieved by laying down a soft tone with a cloth and then lifting the graphite off the paper in swirling motions with a kneaded eraser. You can even get a blotchy effect by pushing the eraser into the paper and lifting it up in quick motions. Render the creature's tentacles using the technique described in Step 11.

Use some opaque white and a fine brush to paint in some swirling smoke escaping from the blast hole, letting it fade as it rises.

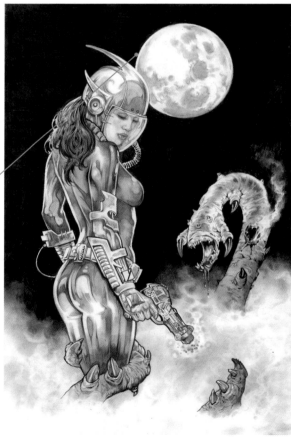

Leave a ring of white around the edge of the moon to give an illuminating effect that will pop it off the background.

Step 14

Final image

Now add the spatter of stars. Use a piece of paper torn into shape to mask any parts that you don't want spattered. Take a toothbrush and dip it in some opaque white, then flick the bristles to spatter the paint in random-sized dots. This will give you an immediate starry effect. You may need to water the paint down to make it spatter more easily – try a few test spatters first. Then take a very fine brush and add larger dots here and there with lines radiating outwards. Finally, take some opaque white and hit any highlights that need a little pop and your sci-fi heroine is finished.

Step 13

Render the moon

Using a medium blending stump, add oval and circular shapes to represent craters on the surface of the moon. As a general rule, to create a rounded effect the shapes need to be rounder towards the centre of the circle, and more elongated ovals nearer to the edges.

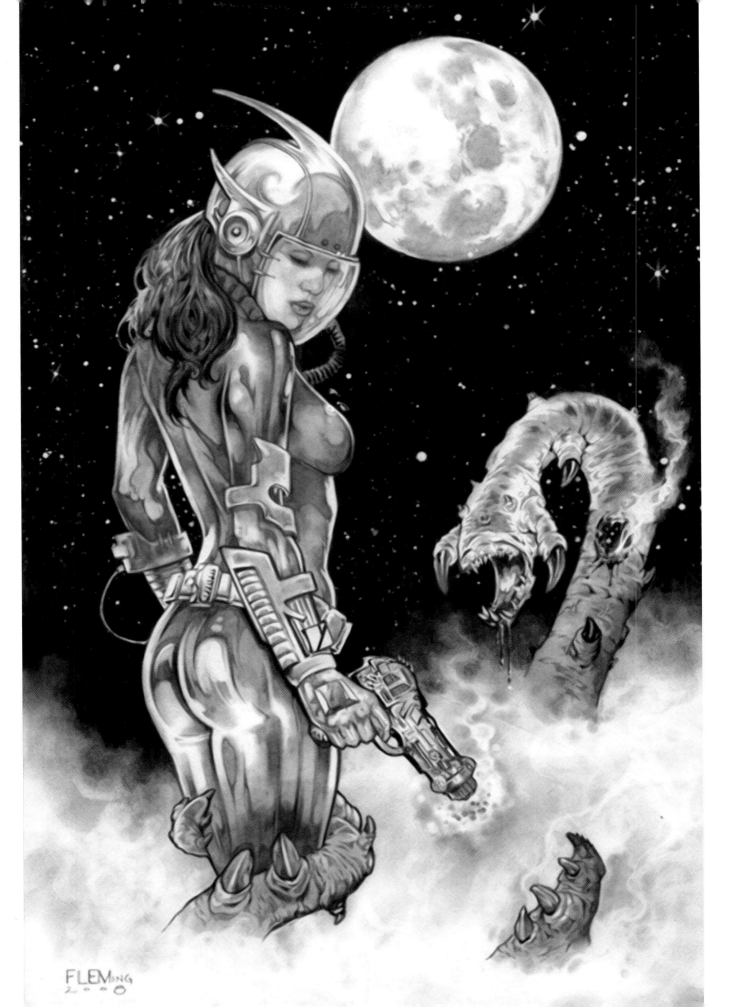

FLEMING
2000

Warrior

From Ancient Greek mythology to Celtic legend, history abounds in strong, assertive women. This athletic beauty is an enticing representation of female heroism. Pencil, eraser and opaque white watercolour are the only media you will need to create this image.

Reference photo
This model photograph was used as a guide to create the rough sketch (below). You may need to improvise to change the costume and weapon, and add a suitable fantasy-themed backdrop.

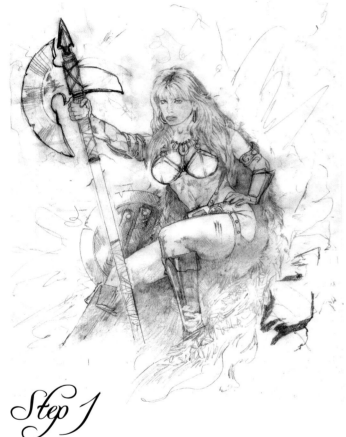

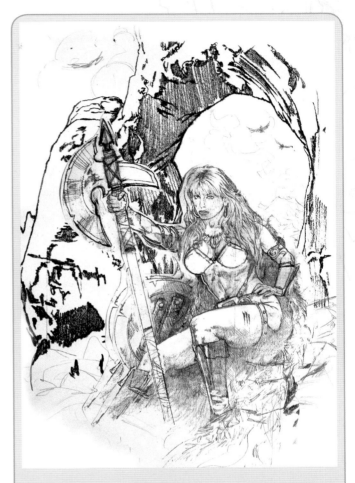

Step 1

Establish the pose

The first task is to create a thumbnail or rough sketch. In general, a thumbnail is much cruder than a rough sketch and is done to establish the pose and general composition. A rough sketch does the same thing, but has slightly more detail on the figure and sometimes a feel for the background. If working from a reference photo (such as the one shown above) you can bypass the thumbnail stage, going straight to a rough sketch. Don't worry if your first sketch is a lot rougher than mine – you don't need too much detail at this stage.

Step 2 (optional)

Finalize the composition

As described on page 32, I use a unique process (which I call 'Frankensteining') to arrive at the final layout. You can work this way – using parchment (tracing) paper and a photocopier to create your image – or if you prefer you can work the initial rough sketch into a cleaner drawing by hand and jump straight to Step 3. However, the photocopier method does save time – instead of having to redraw parts that are out of proportion or scale, you can simply enlarge or reduce them on the copier and rework them into the final layout.

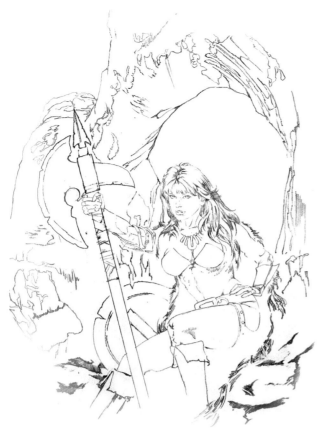

Step 3

Transfer to final media

When you are happy with your final layout, lay your Bristol paper over the copy on a light box and transfer the image in pencil. It is best to use either a .03 or .05 mechanical pencil with an HB lead for this. There is no need to transfer every tiny detail; this is just a guideline to use as you render your image.

When rendering the hair, treat the forms as solid shapes and not as individual strands. Block in and shade the dark shapes around the perimeter of the face first.

Take care when rendering the pupils as even the slightest error can result in the figure looking cross-eyed.

Start to render

You can now begin shading and bringing your drawing to life with a variety of pencils and blending stumps, along with a soft cloth and kneaded eraser. As the face is usually the most important part of an image, it is a good idea to start there. Begin by lightly filling in the darker areas to establish the shadows on the face and in the hair. Using a fine-tipped HB pencil, start rendering the detail in the eyes and lips.

Step 5

Lay in the shadows

Start laying in the shadows with a .07 mechanical pencil with a medium to soft lead (HB or 2B). Fill in as many of the shadow areas as possible – this will give you a good sense of the figure and how the values of the background will work with it. Be careful not to press too hard with the pencil; even though these are the shadow areas you want to build up the values gradually.

Make sure that your darker values work with each other and don't just fall away into a flat black.

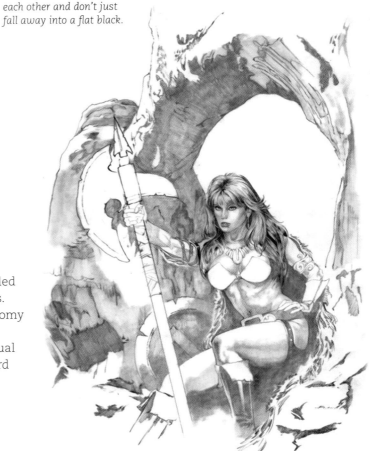

Step 6

Blend and smooth the pencil

Pick up a large blending stump or soft cloth. With medium pressure, start rubbing the areas that you filled in during Step 5 to soften and smooth the pencil lines. Start to flesh out the shadows and details in the anatomy and clothing using the graphite left on the blending stump from shading the background. Using the residual graphite will give you a nice soft tone without the hard lines and grain associated with pencil.

ARTIST'S TIP

Always use a blending stump, a soft cloth or tissue paper for smudging and blending pencil – never use your finger. Fingers leave behind oils that have acid in them. This will eventually turn the paper yellow and affect the life of the artwork. Even when you are shading with the blending stump or cloth, don't rest your hand on the drawing without putting a piece of scrap paper underneath it first for protection.

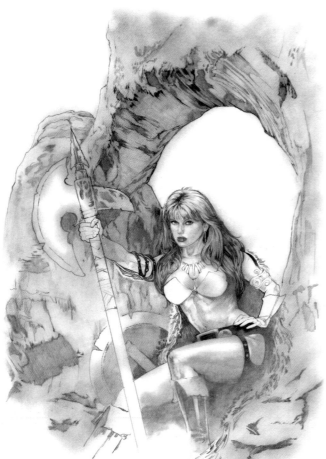

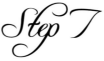

Step 7

Establish the darker values

Using a soft cloth, rub and blend the background to get rid of all the white of the paper in the rocks. You want the viewer's attention to focus on the subject not the background, so make sure the details and highlights are mostly located on the figure. After you have softened and blended the medium tones in the drawing, take a 2B pencil and with slightly more pressure, start to darken in some of the shadow areas and watch the drawing come to life.

Step 8

Use shading to lift the figure off the background

With 2B–4B pencils, darken in areas that will lift the important elements of the figure off the background. For example, if you darken behind her right arm and axe it pops these parts off the page. Doing the same thing on the side of her head against the lighter background has a similar effect. Repeat this process under her left arm, too.

The contrast of dark edges against light background and vice-versa is key in making your drawing leap off the page and have a more 3D appearance.

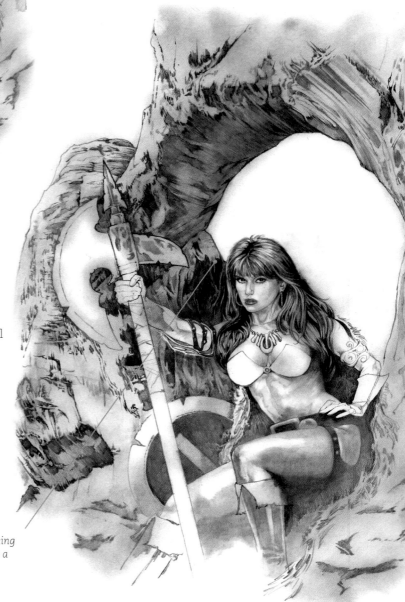

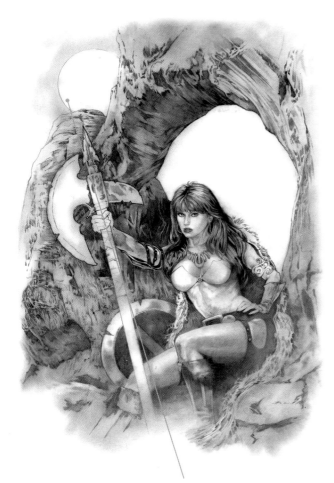

Step 9

Check the image and render the sun

At this point you have most of your values established. Double-check to make sure there aren't any distracting areas that take the attention away from the figure. The shadow in the rocks on the lower left-hand side is a little strong so soften it with a soft cloth. Use a circle template to draw in the outline of the sun with a 2H or 4H pencil. Remove the template and shade around the edge with a soft cloth or large blending stump, leaving the circle white. If you get some shading inside the shape, clean it up with a kneaded eraser.

Leaving some shading inside the circle will create a hazy or cloudy effect around the sun, which you might prefer to a sharp hot sun.

Step 10

Detail the figure and the landscape

Now work on the details of the costume and weapons. When detailing the axe, notice that even though there is shading added, the overall shape remains lighter than the background. This is important to keep the figure popping off the paper. As long as the light and dark values work together, you can add as much or as little detail as you like. To add more 3D quality to the rocks, use a kneaded eraser to lift some of the graphite off the edges, creating the effect of the sun sidelighting them.

The kneaded eraser is a great tool for gently lightening areas that are too dark or need softening, especially skin tones.

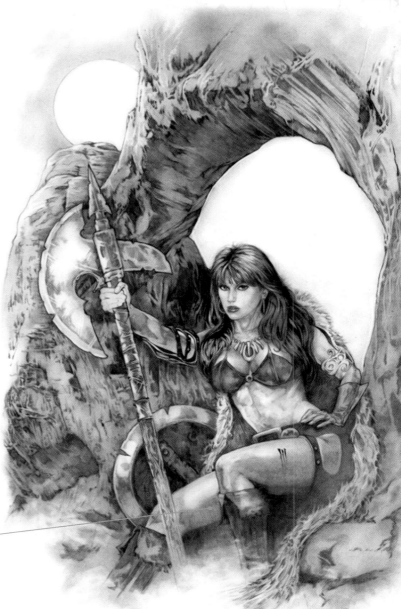

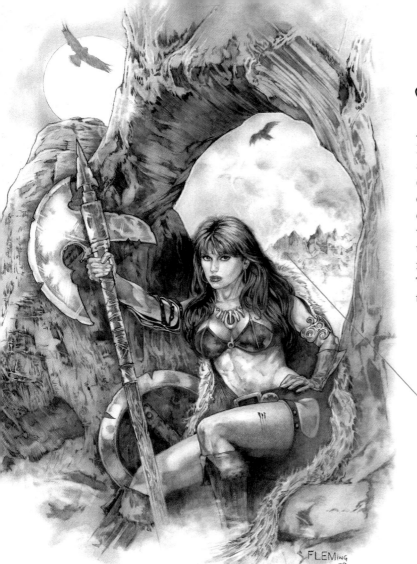

Step 11

Add atmospheric details

Make your drawing more dynamic and atmospheric by adding a mountain and some clouds over her shoulder. Not only does this establish more depth in the image, but it also creates a tone that pops the light edge of the warrior's fur cape off the background. Adding the circling birds is a simple device that many fantasy artists use to add drama to their images. They work so perfectly with this subject that they just have to be included!

To make sure the figure is brought forward, keep the tones of the distant landscape light so that they contrast with her darker cape and hair.

Step 12

Final image

In the last stage, darken all the areas that will add depth to the image using a 6B or 8B pencil, including inside the shield, down the middle of the axe handle, under the arms, inside the cape and a little in the rocks. The final step is to enhance the pure whites. Using opaque white watercolour, paint in all the extreme highlights such as the outlines, the whites in the eyes and the highlights on her jewellery with a very fine 10/0 or 18/0 brush. You will be amazed how much life the pure whites add to the drawing and put the finishing touches on your masterpiece.

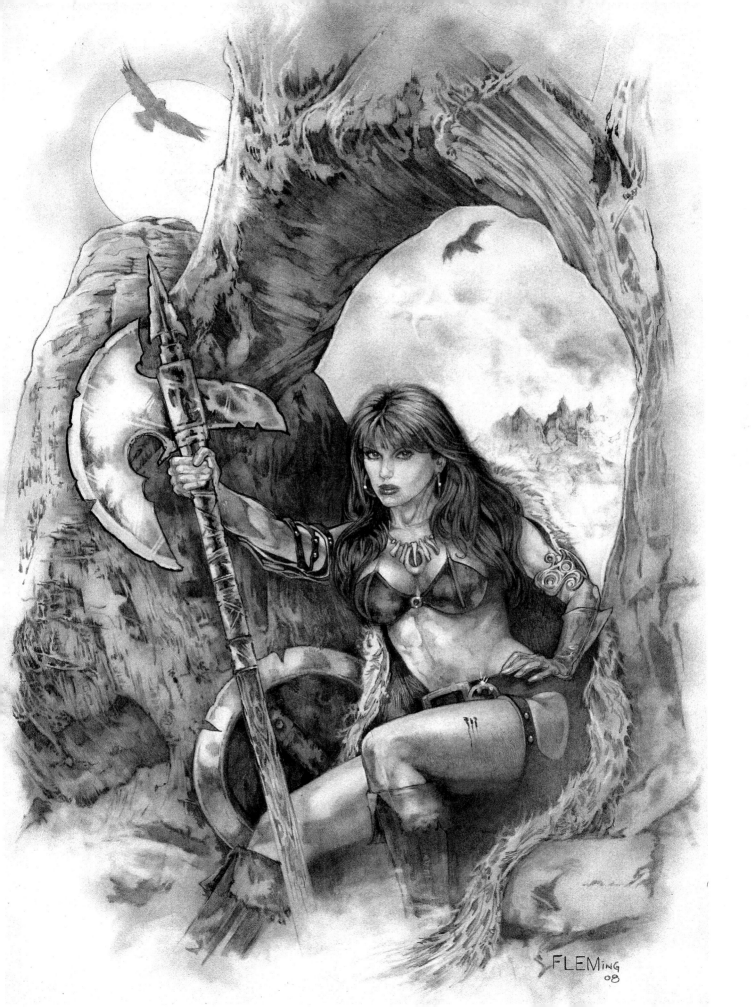

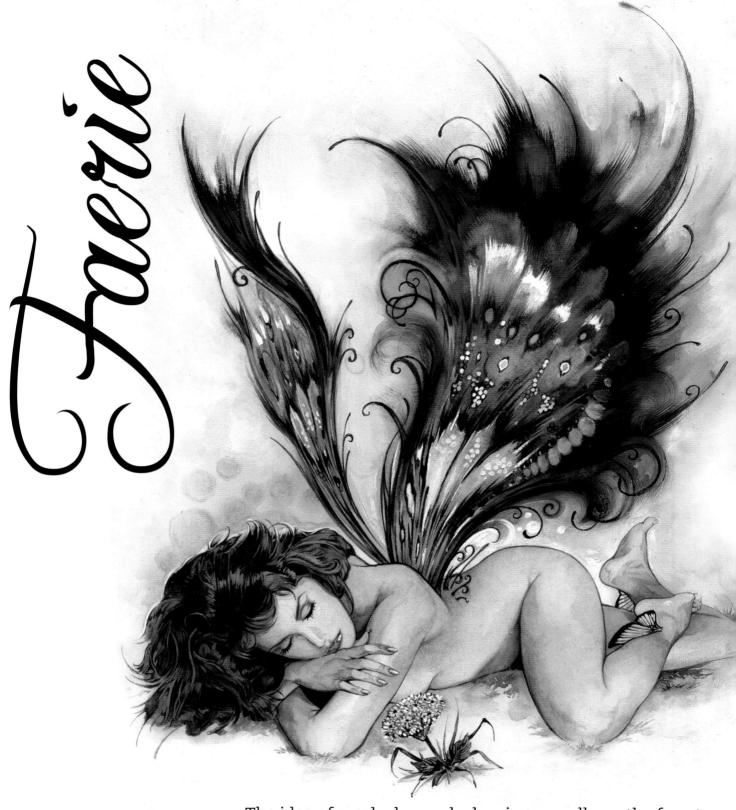

Faerie

The idea of a naked nymph sleeping soundly on the forest floor is so appealing that every fantasy artist will want to have a go at making it the subject of a watercolour painting. Created with pencil, watercolour, water-soluble pencil and fine-tipped marker, it is a matter of a few simple steps for you to recreate this fantastical image for yourself.

Step 1

Plan the image

The first step is to make a quick thumbnail drawing of the basic lines and shapes that you want in your image. This thumbnail is actually quite faithful to the final image with regards to the pose, because an accurate photo reference was used, so there was no need to try out different poses. The original plan was for her to have dragonfly-style wings, and to include some bees flying around her.

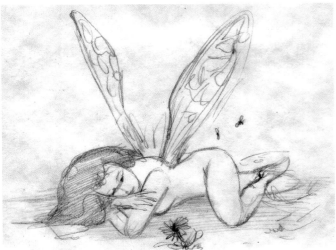

Experiment with the style of the wings to allow for maximum movement and colour in the final piece.

Step 2

Create the composition

Do a figure study from the photo reference and sketch in a general feel for the wings. Leave the bees out, as they look like flies, which has negative connotations. Draw out the figure first on parchment (tracing) paper, then place a separate piece of parchment over the figure and sketch the wings on top. This will allow you to try a few different styles of wings without erasing and losing each version. When you have chosen a style that you like, tape the layers together and you have your final layout.

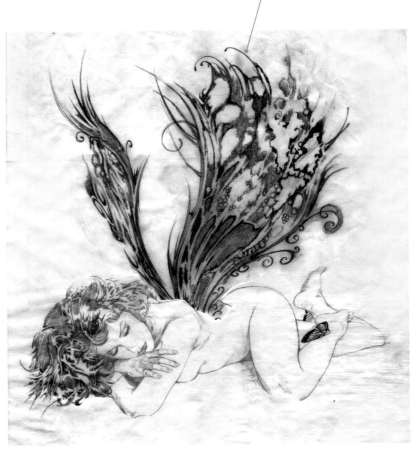

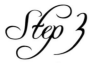

Step 3

Transfer to final media

Using a light box, lay your watercolour paper over the
layout drawing and transfer your image across. It is not
necessary to draw in every detail in the wings because
these will be rendered with painted effects that can't
be achieved in pencil. The basic shapes of the wings are
all that are necessary as a guide. Establish some detail
in the hair at this stage, following the photo reference
closely. Finally, add the foreground element, the flower,
which you can place strategically to cover up her breast.

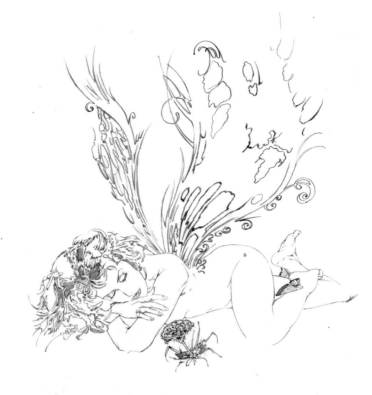

Step 4

Wash in the first tones

The first step of the actual painting
process is a light wash of burnt
sienna to establish the shadows,
basic forms and body contours
of your figure, again based on the
photo reference. Do not get too
dark at this point – the key is slowly
building up layers.

*Use a sable watercolour brush No. 1 or
2 for the larger washes and a 10/0 for
the details of the face and outlines of
the body and hair.*

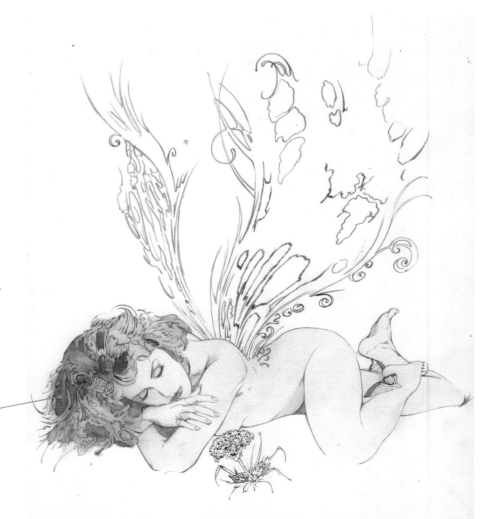

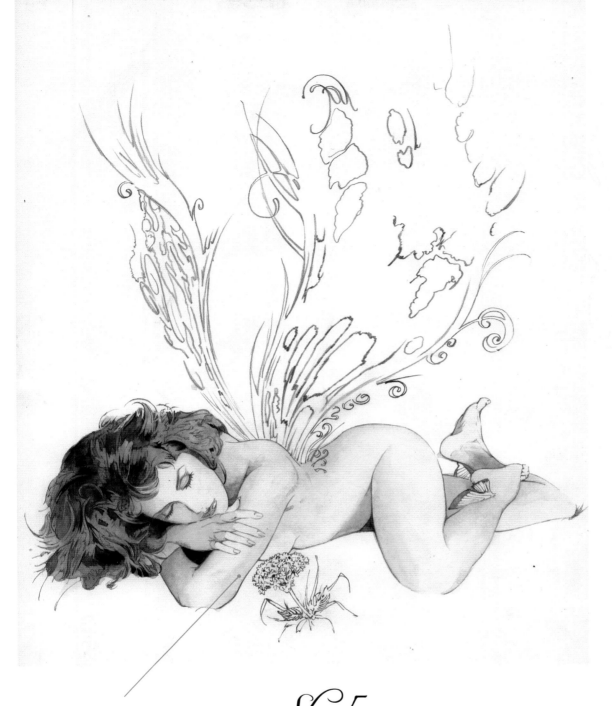

For the warmer flesh tones, lay in light washes of raw umber mixed with a touch of cadmium red using a No. 2 brush.

Step 5

Paint in the flesh tones and hair

Lay in some darker areas in the hair with burnt umber. The beautiful thing about watercolour is that it is a transparent medium that, when layered up, creates a vivid richness by letting some of the bottom layers of colour show through. Lay down the colour in light washes – the aim is to maintain a soft, even light source against a light background so gradually build up the outer edges of skin tones and let soft highlights run down the middle of the forms. This will create a pleasing contrast against the background, while giving a nice volume to the figure.

Start to add the details

Work up some detail in the hair using a dark brown hard-lead coloured pencil to start defining the shape, strands and flow of the hair in the darker areas. Bring out and define some of the outer edges of the figure with a lighter brown or reddish-brown coloured pencil. Drop in some green tones to the flower and darken the tips of the ankle wings with a touch of Payne's grey and a fine brush.

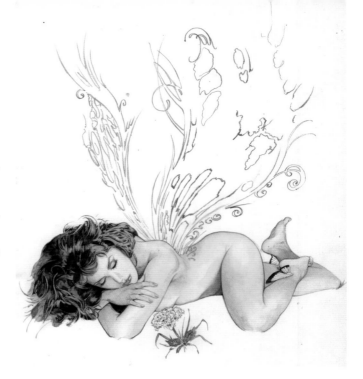

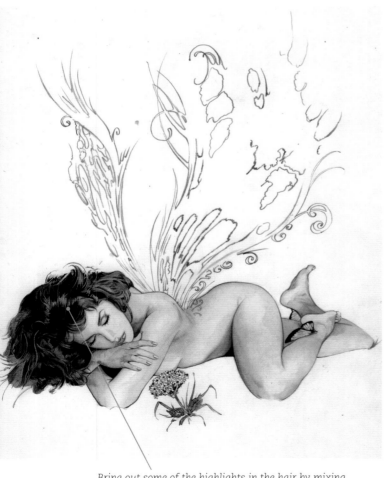

Bring out some of the highlights in the hair by mixing opaque white with a touch of blue. Don't make the highlights too white though, or it may look like her hair is wet or made of plastic.

Step 7

Deepen the skin tones and hair

Enrich the skin tones by adding light washes of violet and cerulean blue to the darker areas. To bring out some of the darker skin tones, lay down a light tone with a 2H pencil and blend it with a medium blending stump for a smooth gradation. If you get too dark in some of the flesh tones, take some opaque white watercolour, add some cadmium orange and burnt sienna to it and cover up the bottom layer. Solidify the hair by adding some darker tones with watercolour, or by shading with water-soluble pencils and washing with water (see Artist's tip, below).

ARTIST'S TIP

When using coloured pencils, I recommend the water-soluble variety, such as those made by Colorific, as this gives you the option to leave them as pencils, or to wash over them lightly with water to convert them into watercolours. These pencils dissolve particularly well, so once the water wash has been added you can barely tell it was once pencil. An important thing to remember is that when water is added, the colour will intensify. So, if you want to keep a soft feel in a certain area, you may want to leave it as pencil and not add water. This will take experimentation until the colour changes become familiar to you.

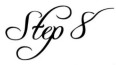

Step 8

Render the wings

When painting the wings, have fun making them any shape, size or colour that you like. If you are worried about losing your drawing under the paint, wait until it dries, then take your pencil and draw over the paint to bring the shapes back out. Start adding colour to the background with transparent washes or using opaque white for a more acrylic feel. Use subtle, pleasant tones that will not compete with the figure.

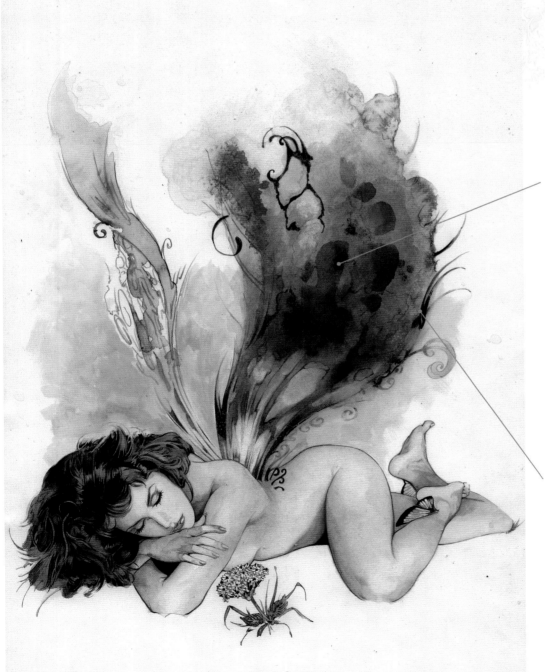

Pick a colour scheme and drop in colour randomly. Let the watercolours bleed into each other to create watery effects.

You can create interesting shapes and swirls with a black fine-tipped marker, which add movement to the image.

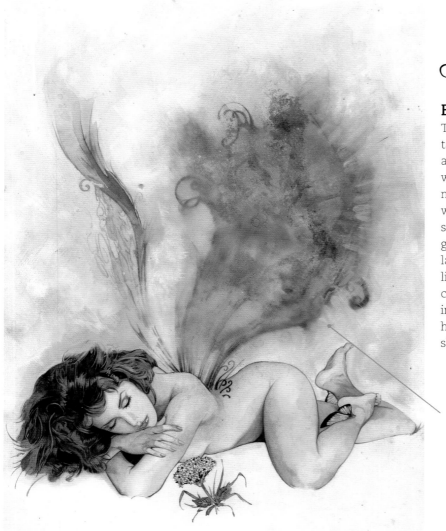

Step 9

Blend and lift the colours

To create a soft, flowing feel to the wings, take some opaque white and softly cover and blend the colours of the background and wings together using a thin milky layer. This may seem like you have just wasted all the work of laying in the colour from the previous step, but as the milky layer is water-soluble it gives you the ability to lay down a new colour layer and softly blend the new layer while lifting up some of the old colour and letting it come through. New colours will be laid down in the next step, but some of the white layer has been lifted up here to let the black swirly shapes come through.

Soften the wings and background with a milky layer of opaque white watercolour.

Step 10

Final image

The last step is to lay down the darker tones in the wings. Take an old stiff-bristled brush and load it up with Payne's grey or black. Press down firmly and stroke in the direction that you want the wings to flow, letting up on the pressure and allowing the stroke to taper off at the end. With dark coloured pencils, create swirly effects and drop in shapes and colours in the centre. Soften the background colour with opaque white watercolour to bring out the shape of the wings more. To finish off, drop in a touch of green around the base of the figure to give the feeling of grass. Let the green blend and fade off to add to the dreamy effect and your faerie is complete.

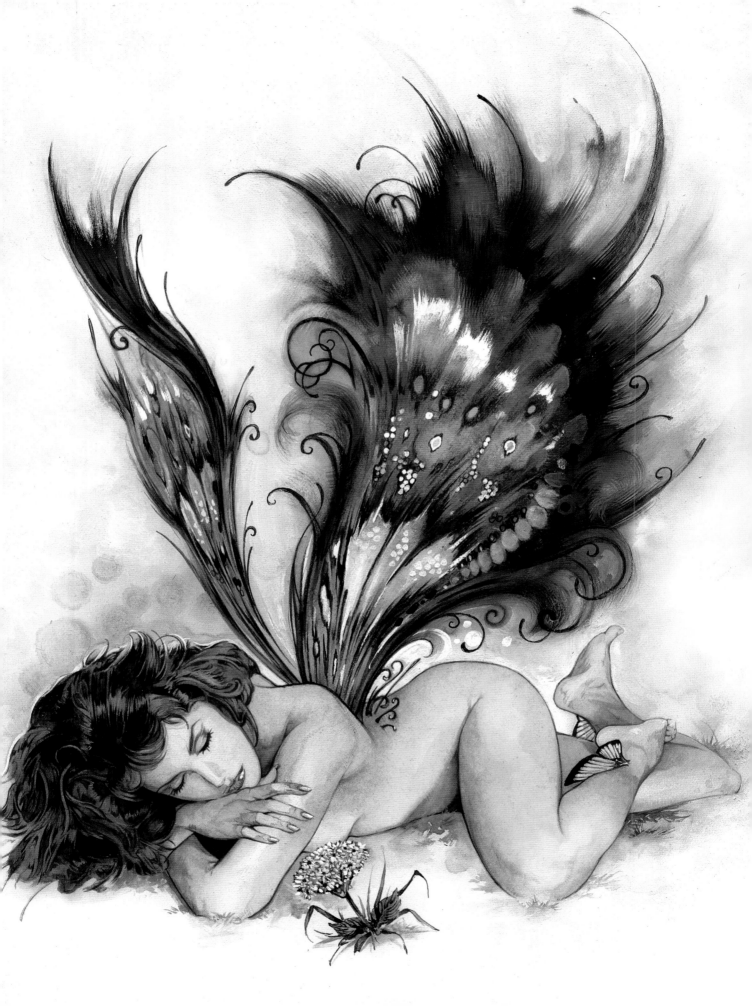

Sorceress

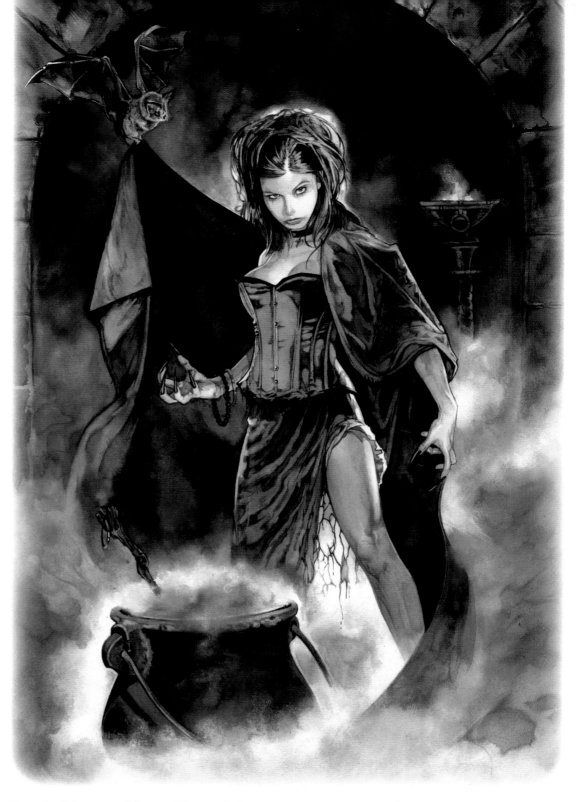

Bewitching and beguiling, sinister yet sensuous, the sorceress is one of the most alluring archetypes in fantasy art. With the ability to cast spells, conjure visions and control elemental forces, she is a powerful figure and the perfect subject for this spine-tingling image, which is created with simple watercolour paints and water-soluble coloured pencils.

When shooting photo references think about the light source. A strong light source can make an otherwise dull and flat image look dynamic.

Step 1

Find photo references

To get inspiration for the pose and features of your sorceress, select a few photo references to work from. This archive shot of a Belgian model shows a beautiful yet threatening expression that is perfect for this figure. Although the hand and arm reference photos show male examples, their positions and lighting are ideal. By elongating the fingernails and reducing the thickness of the fingers and arms, you can create limbs that are more feminine in shape.

Step 2

Create a thumbnail sketch

Next, create a very quick doodle to decide upon the pose and composition of the piece. Refer to your photo references to sketch the position of the face, hands and arms.

For a seductive pose, tilt the head downwards with the eyes glaring in full contact with the viewer.

Position the hands with tension in the fingers and elongate the fingernails for a more aggressive and threatening posture.

Pose the figure in a wide stance and expose one leg to create a strong, confrontational, yet sensuous stance.

Step 3

Transfer your thumbnail sketch

Tighten up your thumbnail drawing, firming up your lines and being sure to erase any unnecessary lines to avoid confusion. Enlarge it to the required size, lay your watercolour paper on top of it and transfer the drawing using a light box. To create a clean white border, apply acid-free artist's tape to the edges of your drawing.

ARTIST'S TIP

To prevent the watercolour paper from warping or buckling when water is applied, spray the back of your drawing with acid-free spray adhesive and adhere it to an acid-free 2- or 3-ply backing board. Use a very thin wash of water to prevent the paper from becoming too wet and spoiling the image.

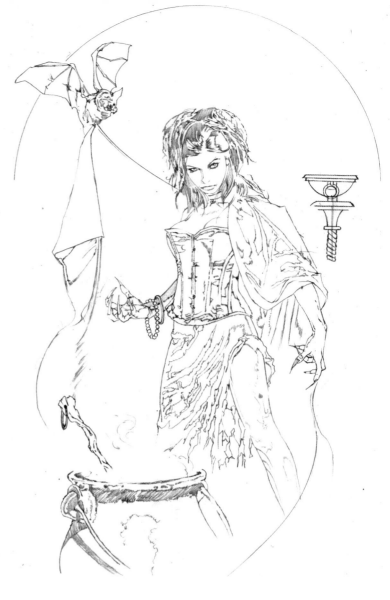

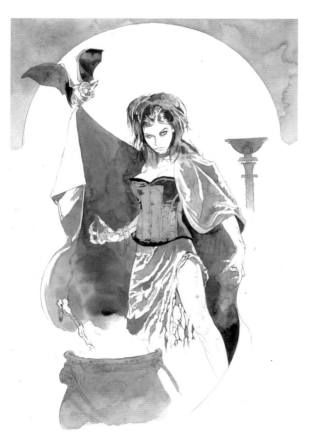

Step 4

Lay in the initial wash

Lay in the initial tones in the hair, costume, cape and background elements with light washes of Payne's grey. Use a soft brush to create a smooth, blended wash. Using greyish and bluish tones gives an effect of dying or sickly skin, giving the impression that the subject spends no time in daylight.

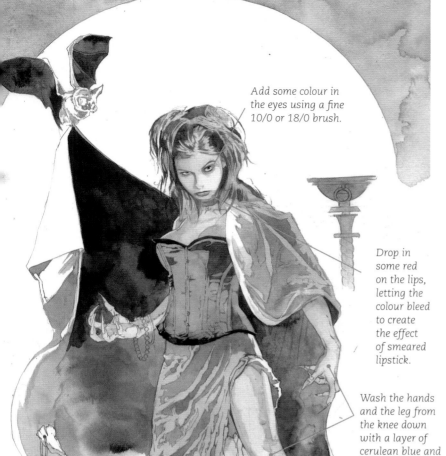

Add some colour in the eyes using a fine 10/0 or 18/0 brush.

Drop in some red on the lips, letting the colour bleed to create the effect of smeared lipstick.

Wash the hands and the leg from the knee down with a layer of cerulean blue and a touch of violet.

Step 5

Build up the colours

To create a pale skin tone, lay in a thin wash of burnt sienna with a touch of cadmium red over the Payne's grey wash. When dry, add colour details following the annotations (left). Think carefully about lighting when applying your basic colours to the costume and cape. A greenish light on the right side of the cape will contrast effectively with the purples in the bodice and skirt.

ARTIST'S TIP

To get a smooth tone without the watercolour drying too quickly and blotching, lay a thin layer of water in the area to be painted before dropping in the colour. This will allow the paint to be moved around without immediate absorption into the paper.

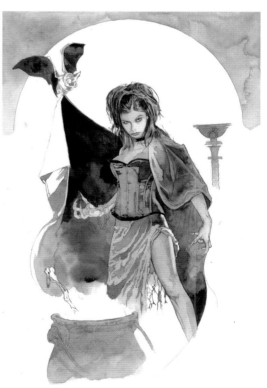

Step 6

Add details in pencil

Use a sharp black watercolour pencil (such as Colorific) or hard-lead coloured pencil (such as Prismacolor Verithin or Col-Erase) to add lines and shading that bring out the flow and shape of the hair, the folds in the cape and the shadows in the bodice. Knowing that you will have a strong light source on the right side of the painting, start creating a contrast between the strongest highlights and the darker areas of the figure.

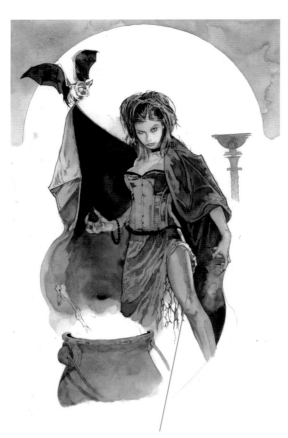

Step 7

Wash over the coloured pencils

With a sharp reddish-brown coloured pencil, define the edges of the fingers, hands and arms. Shade the legs by adding shadow down the middle of the thigh, kneecaps and calf. Take a wet brush and dab the edges around the fingers and hands and down the leg. This will dissolve the coloured pencil to paint and still leave a crisp line around the edges. With a brown tone, wash in a layer over the cape leaving the green tone on the outer edge. Bring out the folds in the cape under her arm with a black coloured pencil, or Payne's grey or black watercolour.

By putting the shadow down the middle of the thigh with a strong light source on the edge, you create a dynamic 3D effect.

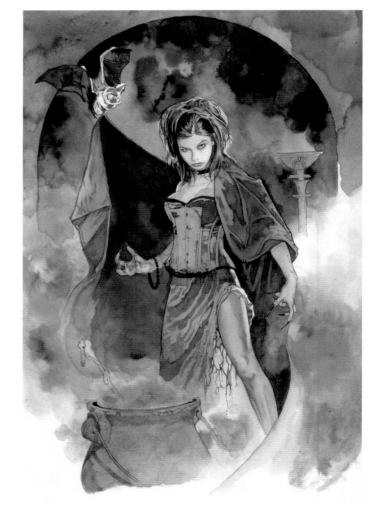

Step 8

Create the atmosphere

With the figure established, start work on the background and the smoke-filled mystical atmosphere. Wet the areas with plain water, then load up a medium brush with paint, dab the damp areas and let the paint bleed into the paper. If you want a sharp, defined edge such as on the archway, just put the water where you want the colour to run and dab only the wet areas. Establish the basic colour scheme by dropping black in the background, blues and purples in the middle-ground and greens in the foreground.

Mix sepia, olive green and opaque white for the mid-tones of the cauldron. Leave the purple underpainting for the lighter tones. Use Payne's grey and black for the darker tones.

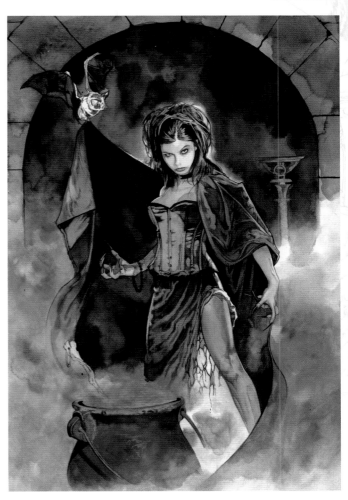

Step 9

Add warmth and render the bowl

When the paint is dry, warm up the background by adding browns to contrast with the blues and purples of the foreground. The smoking bowl in the background should be kept fairly monotone. Use sepia with black for the darker tones, and sepia with a touch of white for the mid-tones. Don't use any real highlights or light tones, as you want it to recess into the background.

Step 10

Deepen the shadows and add highlights

Use black pencil to define the outlines of the stones in the archway. Draw the lines of the archway to converge into the figure, which will lead the eye to her. Use the same pencil to deepen some of the folds in the dress and cape. Go around the edge of her hair with opaque white watercolour, blending and letting the white fade into the background. This raises her hair off the background and creates a glowing effect. With the same white, enhance the light edges on her dress and leg, and increase the light area under her leg to bring it forwards. Add some highlights and blue tones to the face to give it a mime-like gothic effect.

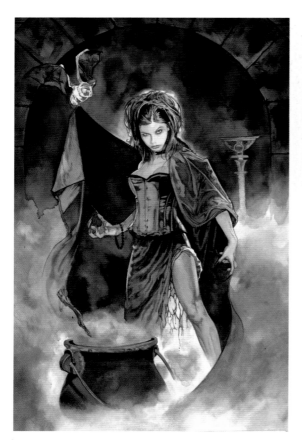

Use a stiff-bristled brush with opaque white and scrub the paint into the areas that you want highlighted. Use more pressure where you want the paint to blend into the layer underneath.

Step 12

Add the finishing touches

There seems to be too much smoke and not enough stone so extend the walls down. Paint the smoke by mixing colours with the opaque white and scrubbing them around. The smoke from the cauldron needs more highlights to create a sense that it is lighting up the underside of her right hand.

Step 11

Evaluate the image and fix any problems

Assess the parts of the painting that are working well, and the parts that need enhancing. The archway is too light and doesn't have enough texture, so darken it, leaving enough light stone to define the edge. The background is also too dull, so take some alizarin crimson and cadmium orange and wash it in to create a fiery effect. Darken and solidify the cauldron by combining Payne's grey and a touch of violet and scrub in the shadow areas with an old stiff-bristled brush. Lighten the smoke around it to pop the edge by mixing opaque white with thalo green and scrubbing to define the smoke coming out of the cauldron.

Step 13

Final image

Paint in the bat following a photo reference, making sure you maintain contrast between the wings and the background. For the mixing stick, use a medium brown base coat, then use a dark brown or black pencil to add the wood grain. For the flame of the smoking bowl, scrub in some orange paint then with a small brush wiggle some yellow paint through the centre of the orange. Add dots of opaque white mixed with yellow to the flame base. To integrate the background and foreground, add darker blue-purple tones in the very back and purple tones to the archway using the scrubbing technique again. Take a good look, if everything looks great, peel off the tape around the edges and your sorceress is complete.

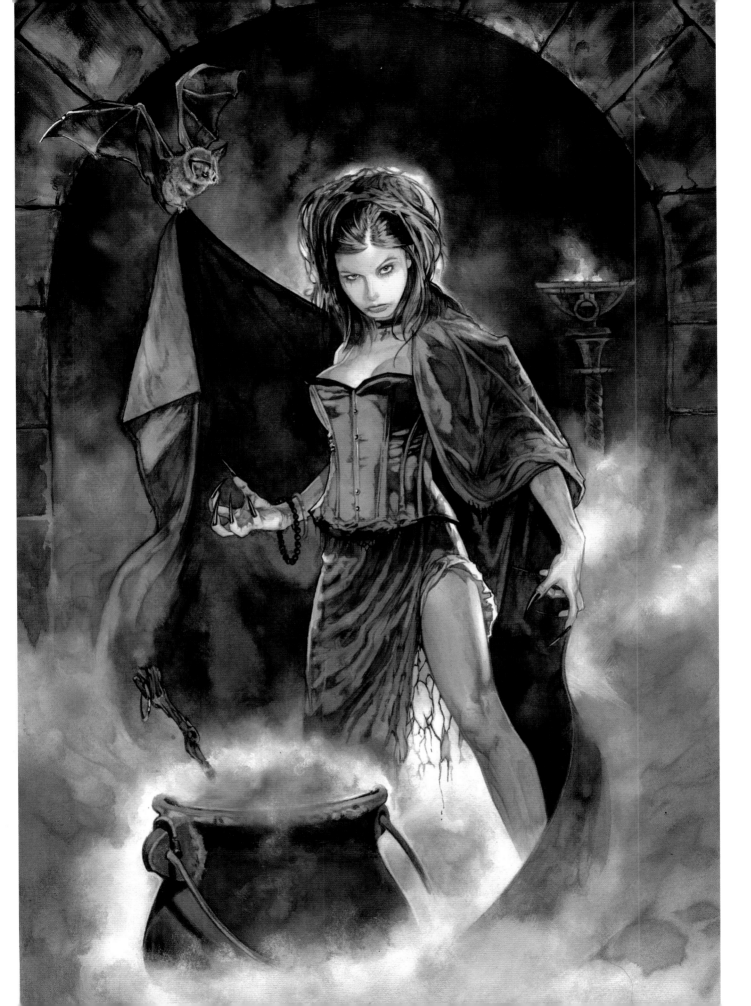

Goddess

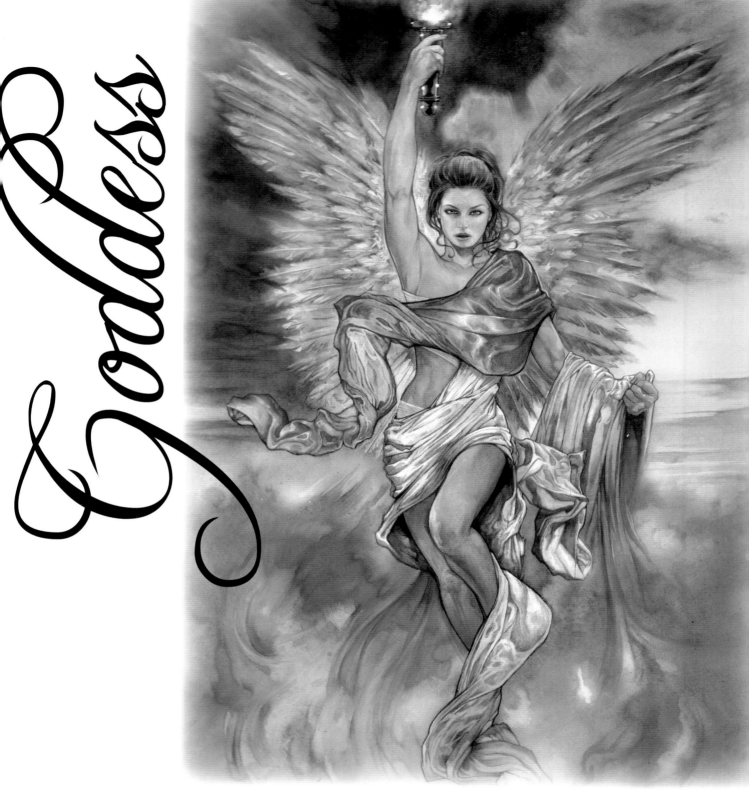

Goddesses are usually associated with positive qualities of love and nature, but some are connected to more destructive forces such as war and discord. This goddess is based on the idea of a Valkyrie from Norse mythology. This image will take longer to recreate than some of the earlier demonstrations but is worth the extra effort. You will need pencils, watercolours and coloured pencils to render it.

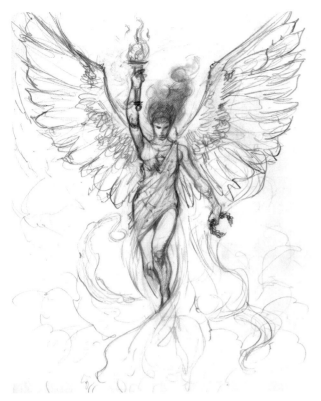

Step 1

Plan the composition

As always, the initial stage is the thumbnail sketch. Working from descriptions of Valkyries found in books and on the Internet, do a quick doodle to establish the general pose and compositional elements. You will find that your final image might actually be quite different from your initial thumbnail, as you will change and refine things at every single stage.

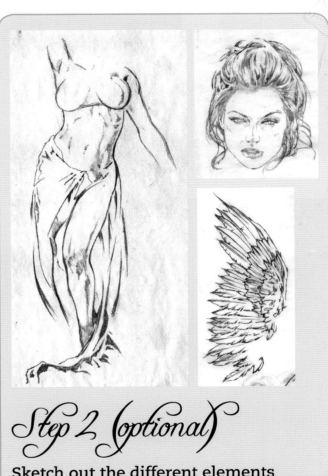

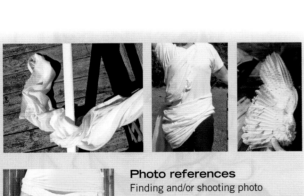

Photo references

Finding and/or shooting photo references is a key stage if you want your image to be convincing. Various references were used for this image including photos for the wings, the pose and the cloth. I will often shoot references of myself for my images. I've drawn the female form enough times to be able to convert my masculine attributes into feminine qualities. You may need to use a female figure in the first place, until you become more practised at drawing womanly forms.

Step 2 (optional)

Sketch out the different elements and create the final layout

As this is a complex image, it is a good idea to sketch out all the different elements in individual studies. When you are happy with each element, use the technique described on page 32 to create a final layout (the layout used for this image is also shown on page 32). If you would prefer to just draw out the final layout by hand, do so then jump straight to Step 3.

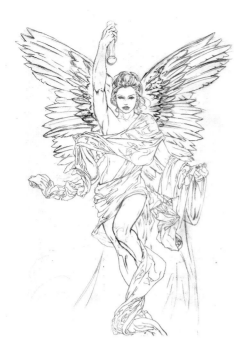

Step 3

Transfer to final media and tighten up

Transfer the final layout drawing to your watercolour paper via a light box. Hot press watercolour paper is recommended, as it is a great surface to paint on. Tighten it up once more, then mount it to acid-free 2-ply backing board. You are now ready to start painting.

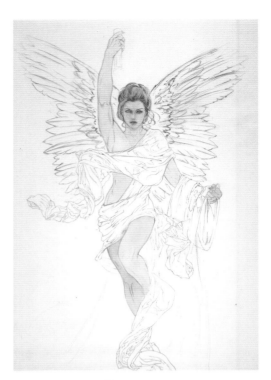

For the lighter areas of the face, mix opaque white with a touch of cadmium orange and carefully blend this into the darker areas in thin layers.

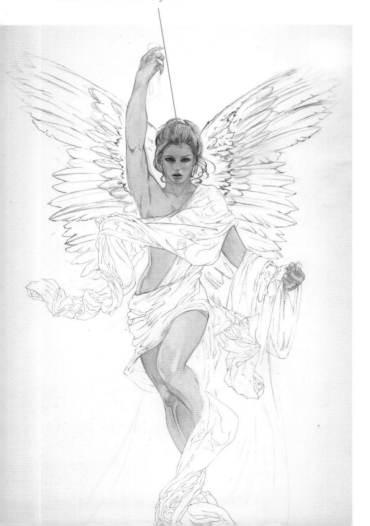

Lay in the first flesh tones and details on the face and hair

First, brush a thin wash of water over all the flesh areas until they are evenly moist. Before the water dries, lay a light wash of burnt sienna with a touch of cadmium red on to all the flesh areas and let it dry. You now have a nice flat tone to work with. Then start on the face. Take a very fine 10/0 or 18/0 brush and start painting in the facial details with burnt sienna, then drop in a flat blue tone for the eyes. Lastly, drop in some of the shapes of the hair to get a general feel for its flow and colour.

Enhance the flesh tones and develop the face

Take a small brush and drop in the shadows on the hands, knees, elbow and chest with burnt sienna and a touch of cadmium red. Add darker washes to define muscle tone, leaving the highlights alone. Develop the face by adding detail to the eyes with sepia and using burnt umber for the lashes. Use a dot of black for the pupil, a dot of white for the highlight (always after the pupil), and a light wash of red-violet around the eyes and eyelids. Continue to build the face with washes of burnt sienna, cadmium orange and opaque white.

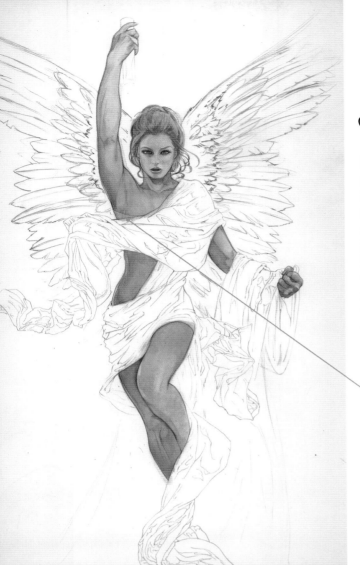

Step 6

Enrich the skin tones further and adjust the costume

Deepen the flesh tones by adding washes of burnt sienna, cadmium orange and opaque white for the medium areas, and cerulean blue with a touch of violet for the darker areas. To create depth in the shadow areas, lay down an even tone of bluish-violet over your sienna wash, let it dry and then paint more sienna tones on top. Her right breast is too exposed, so add a sheer cloth by taking some opaque white and swiping it a few times in the direction you want the cloth to flow.

For the sheer cloth, use the white thinly, as you want the tones underneath to show through.

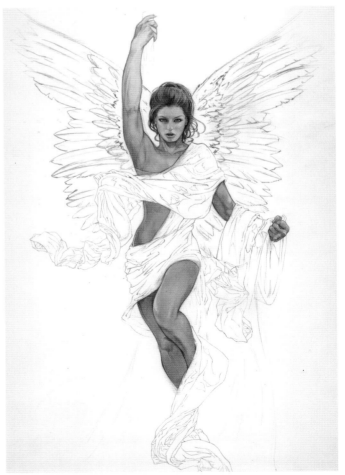

Step 7

Progress the musculature and hair

Develop the musculature by darkening areas of the body (the kneecaps, shins, thighs and her left bicep) using raw umber and a touch of burnt sienna. Bring out some of the medium tones further with burnt sienna and a touch of cadmium red. Using washes of burnt sienna and burnt umber, lay in the darker shapes of the hair. Let the darker washes dry, then add details and lines using burnt sienna, medium brown and dark brown coloured pencils.

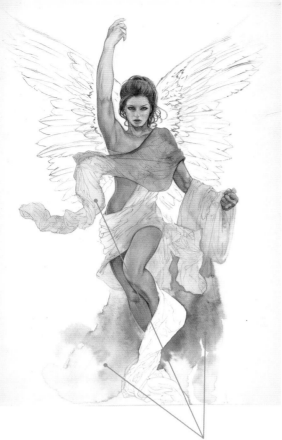

Use watery washes to avoid the paint becoming too dark or thick.

Step 8

Render the cloth

Start with the fabric around the upper torso and lay in a wash of cerulean blue with a touch of thalo blue. Repeat on the cloth around the lower body using Payne's grey with a touch of violet. To create the abstract shape and flow to the background wash, try to get the cloth to fan out at the bottom to draw the eye upwards to the figure. This will create a shape that acts as a solid base for the figure, strengthening the composition.

Step 9

Adjust the cloth colouring

When the washes are dry, decide if you need to make any adjustments to the base colour. For a warmer blue for the upper cloth, lay a wash of violet over the cool blue to give a richer, more vibrant colour. Look at your reference photo of the cloth and bring out the folds and shadows with medium washes of Payne's grey and a normal HB pencil.

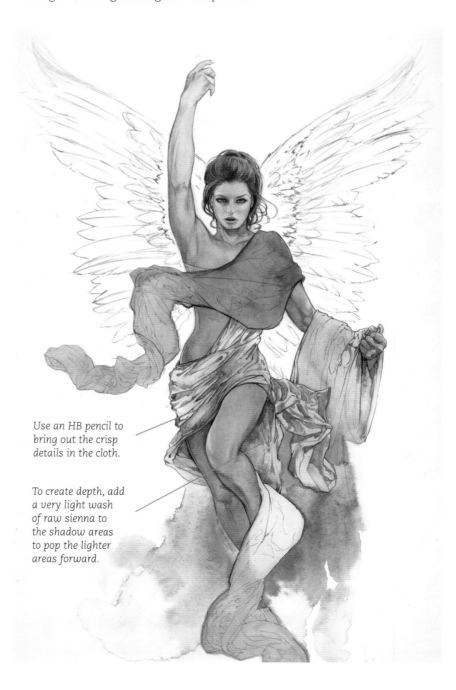

Use an HB pencil to bring out the crisp details in the cloth.

To create depth, add a very light wash of raw sienna to the shadow areas to pop the lighter areas forward.

Step 10

Add definition to the cloth

Continue to render the cloth draped on the arm and snaking from the legs. Once you have brought out the medium and darker tones of the lower cloth, add some highlights with opaque white. Soften any hard edges using a flat damp brush to stroke lightly in the direction of the cloth flow. Use a dark blue watercolour pencil to define the edges and fill in the darker shapes of the upper cloth.

ARTIST'S TIP

To give the cloth a silky texture blend the darker pencil areas by laying down a light, clear wash of water over the entire shape. This will break down the watercolour pencil and blend it into the base of lighter blue tones. Once dry, add highlights using opaque white and a touch of cerulean blue and repeat on the lower cloth with the opaque white to see the cloth really start to come alive.

Step 11

Wash in the base background tones

Using a large, flat wash brush and starting from the top of the painting, lay in tones of cerulean blue and thalo blue using broad long strokes from one side to the other. Let the colour fade out as it gets closer to the middle by adding more water to the mix. Do another wash of raw ochre and yellow ochre the same way, starting from the bottom, fading to the middle again and overlapping slightly with the blue wash. Wash right over the background cloth and the lower cloth to help integrate them with the background.

Lay down a clear water wash first to ensure that the background tone is smooth.

Step 12

Create the dramatic sky

To add the clouds, use a firm, short-haired flat brush with Payne's grey and scrub in the motion and direction that you want the clouds to flow. The clouds should converge on the figure to create a sense of drama and lead the viewer's eye to the focal point. To get the smoky effect of the clouds on the right-hand side, use a stiff, short-haired round brush with Payne's grey and scrub the edges of the clouds with swirling motions. The clouds on the right need a touch of violet in them to integrate them with the cloth colours.

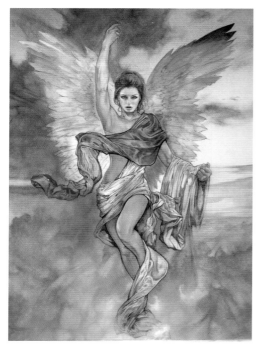

Step 13

Render the foreground clouds and wings

To create the foreground clouds, use the same brush with raw umber and scrub until you get the feel and motion right. Add a touch of violet and opaque white for a smoky feel. Pop the raised hand by mixing white, sienna and yellow ochre, then redefine the outlines with a brown pencil. For the wings, mix black with opaque white for your base tone. Start defining the feathers on each wing using a small brush. Make the wing against the dark background slightly lighter and the wing against the light background slightly darker.

Bring out detail and form in the feathers with a .03 HB mechanical pencil and a blending stump.

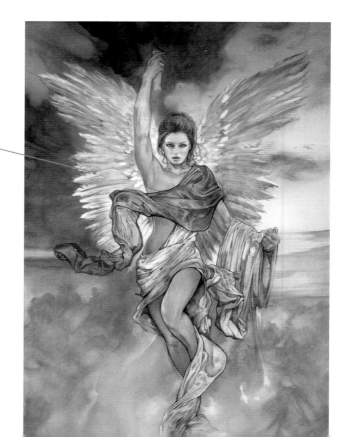

Step 14

Detail the wings and evaluate the image

Render the wings in the same way as the cloth, then lighten some areas and the tips of feathers with watered-down opaque white. Step back and assess the colour values. The area behind the raised hand needs to be darker for the flaming torch to work effectively, so drop in some Payne's grey and Prussian blue to create a darker cloud. At the bottom, add some form and life to the clouds and cloth by mixing opaque white and yellow ochre and highlighting the clouds and the edges of the cloth.

Step 15

Add movement and dynamism

Give the painting a dynamic feel by adding lots of swirls and motion in the cloth and clouds surrounding the figure (see Artist's tip, below). Create abstract forms and movements using the white/ochre mix for the lights, and violet and raw umber for the darks. Keep layering light colours and darker colours until the values work well.

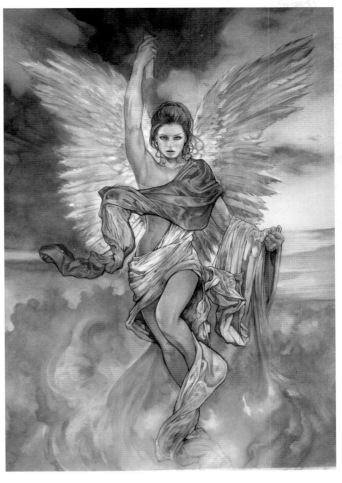

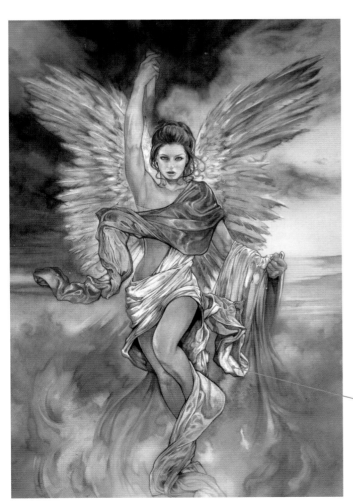

Step 16

Enhance and exaggerate the shapes and folds

When you see shapes that appeal, take a raw sienna pencil, which has a nice golden hue and a medium value, and enhance the forms by blending the edges softly (make sure the paint is dry first though). Enhance the folds and highlights in the cloth with opaque white straight out of the jar to get a pure white highlight. Go back to the wings and bring out the shapes of the feathers using HB or 2B pencils and blending stumps.

If any highlights seem a bit hard, take a damp short-haired stiff brush and lightly brush back and forth to soften the whites.

Step 17

Assess the image and fix errors

Take a break from your piece and then come back with a fresh perspective. Look again and evaluate the image as a whole; you will undoubtedly notice things that were not evident before. For example, her legs need more definition so darken her kneecaps and shins with careful washes of burnt sienna and Indian red, along with burnt carmine and a reddish-brown pencil. With a very light touch of white and cadmium orange, define the details of the torso a bit more, too. Add a hint of the sheer fabric under the blue cloth, using the same technique as in Step 6, to give a little more contrast to the blue.

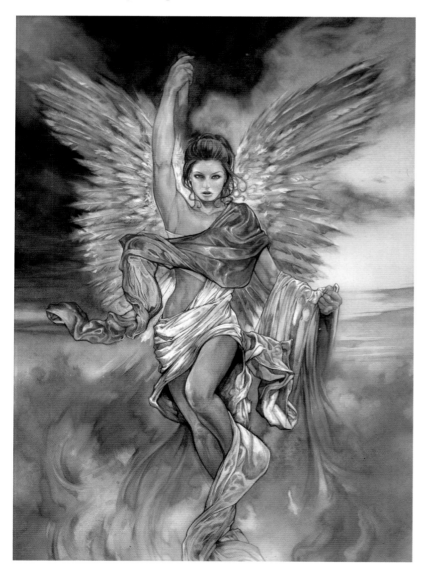

Step 18

Final image

The final task is to paint in the torch. With a normal pencil, draw in the outline of the torch head. Mix raw umber, yellow ochre and a touch of opaque white and paint in the shape of the torch. When the paint has dried, add the dark shadow down the centre of the handle with sepia and dark brown pencils. With a very fine brush, add bright highlights on the handle and torch head. With a stiff short-haired brush and some thick cadmium red, scrub in the basic shape and size of the flame. Do the same thing with cadmium orange slightly smaller inside the red shape. Repeat with lemon yellow smaller still, and finally add a pure white highlight in the centre. The final touch is to add more of the sheer fabric to the hip and you have finished your goddess.

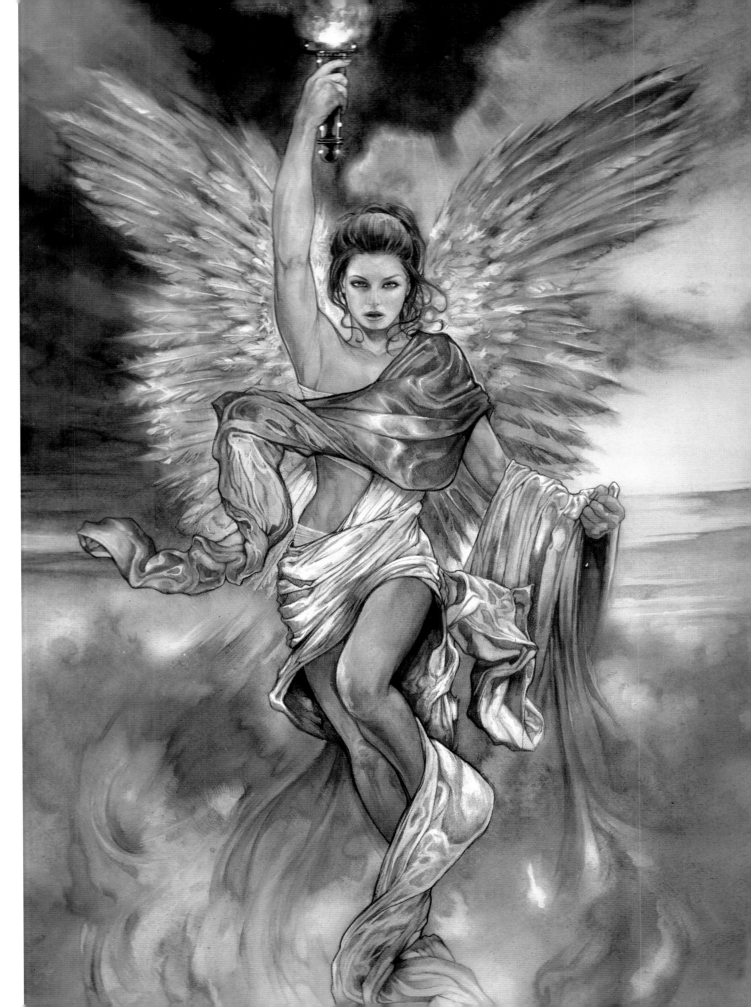

Gallery

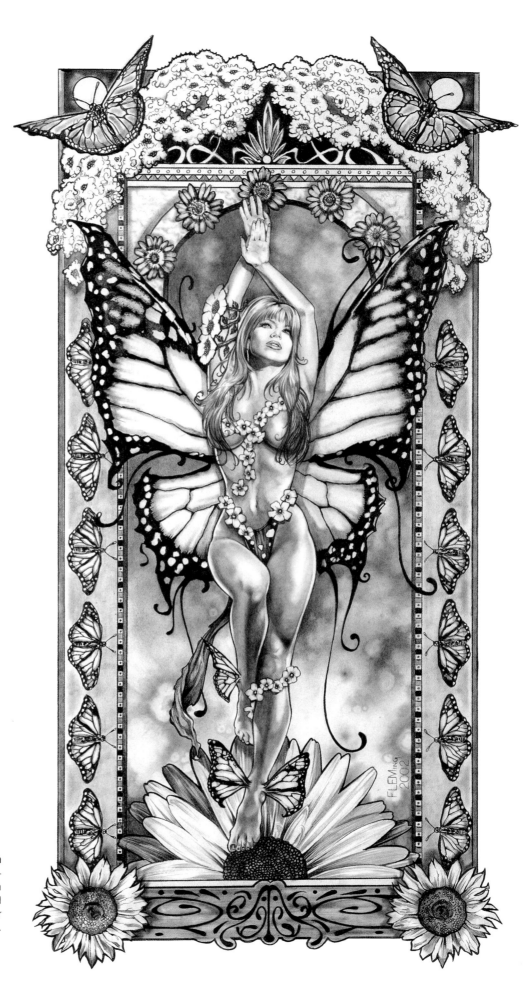

Monarch
An alluring Art Nouveau-
inspired limited edition
print featuring model and
friend Stacy E. Walker
(www.stacyewalker.com).

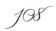

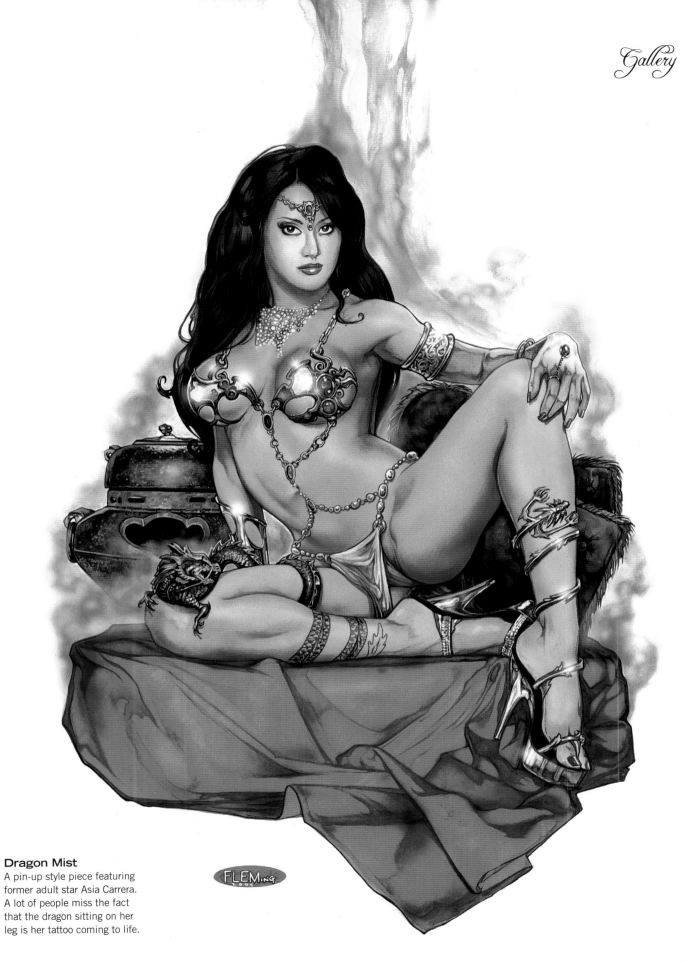

Dragon Mist
A pin-up style piece featuring former adult star Asia Carrera. A lot of people miss the fact that the dragon sitting on her leg is her tattoo coming to life.

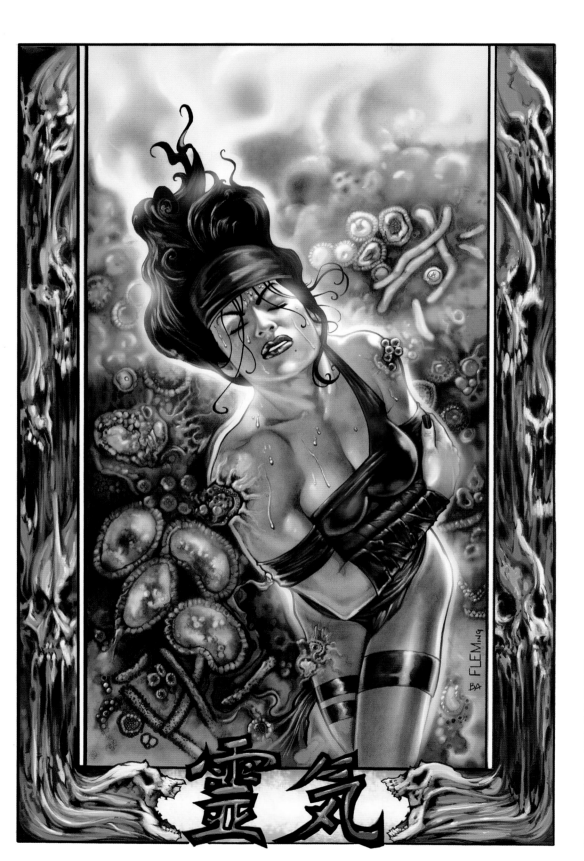

Elektra (opposite)
Cover image for issue 33 of the classic Marvel comic, showing the Greek ninja with sword and sai and a perfectly toned physique.

Elektra (this page)
Cover image for issue 34 of the comic. The heroine is stricken with a rare Asian virus in a story entitled 'Fever'.

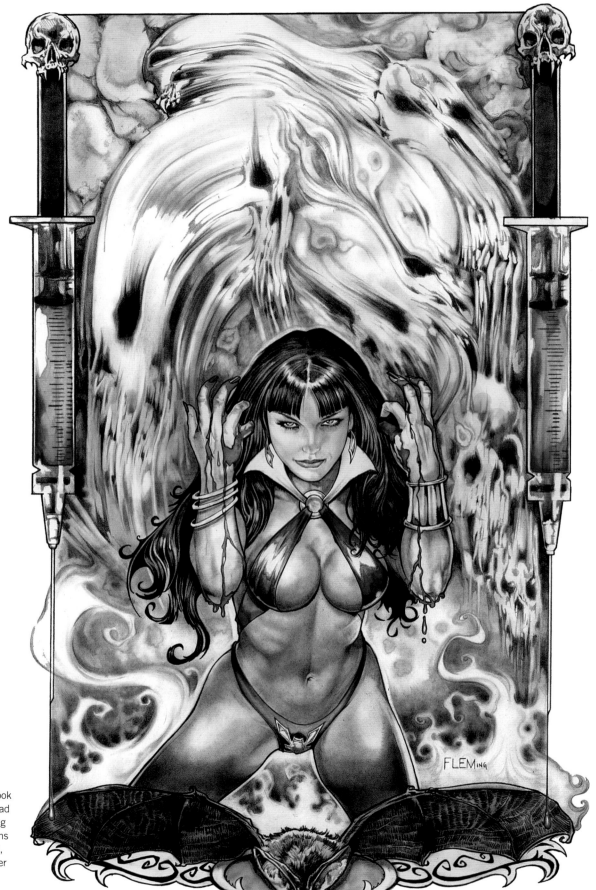

Vampirella
This is one of my favourite comic book covers to date. I had a lot of fun drawing the swirling demons in the background, using a photocopier to distort them.

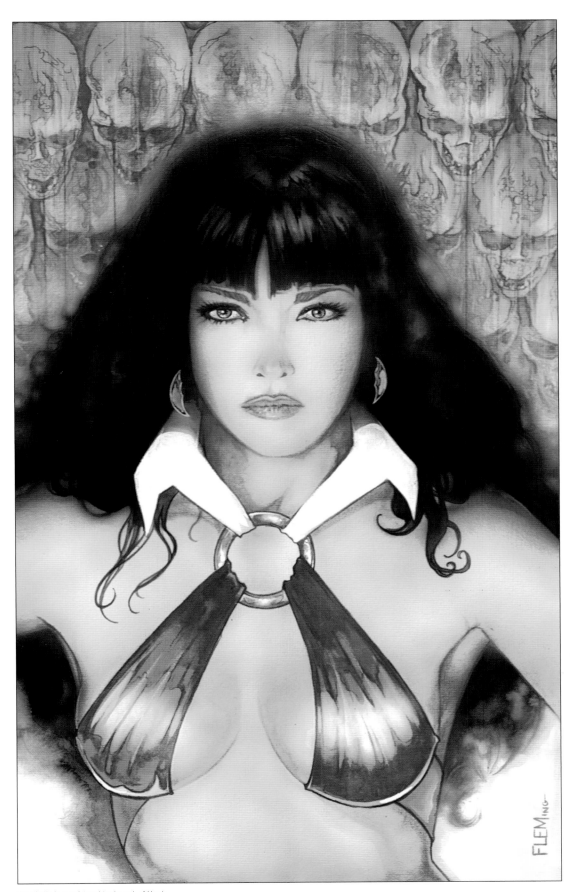

Vampirella
This was an experiment using coloured Canson paper. The flesh colour is actually the paper colour coming through not the white.

Vampirella is a registered trademark of Harris Publications, Inc. used with permission.

Ezra

The demon hunter in chains. This was the cover image for special edition #1 for Arcana Studios.

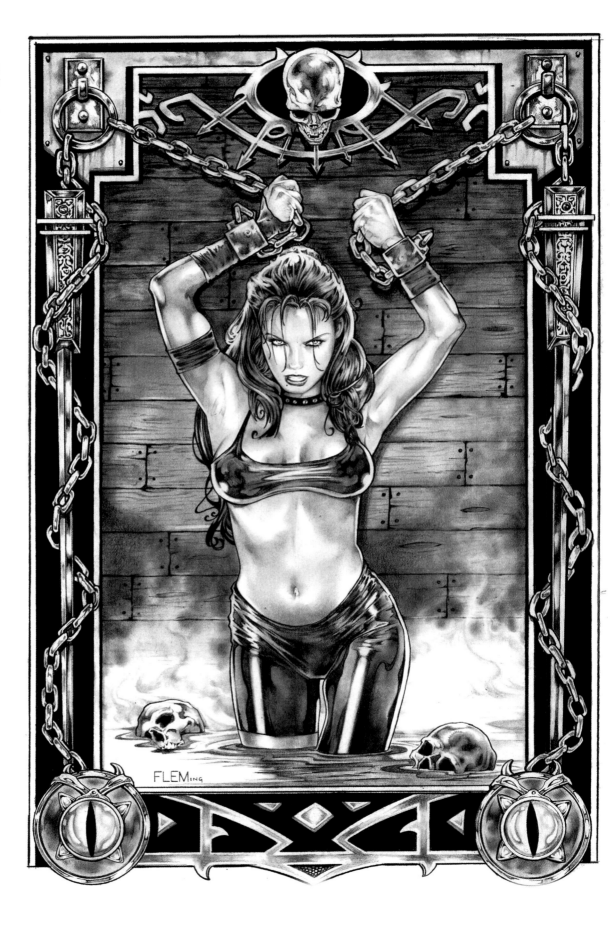

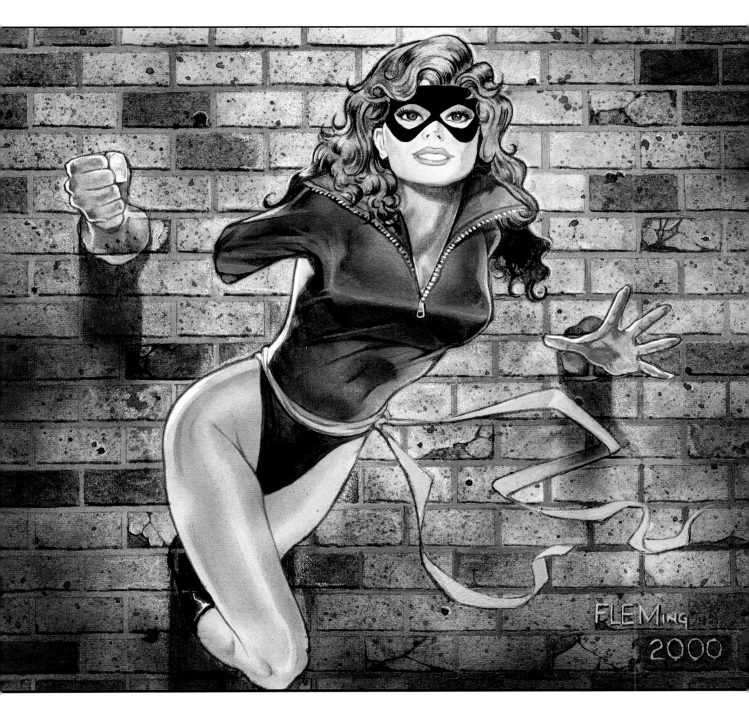

Shadowcat
This painting was done for Marvel Comics and Wizards of the Coast for an X-Men trading card game.

Leopard Queen

One of my first limited edition prints featuring superstar fitness model, Amy Fadhli.

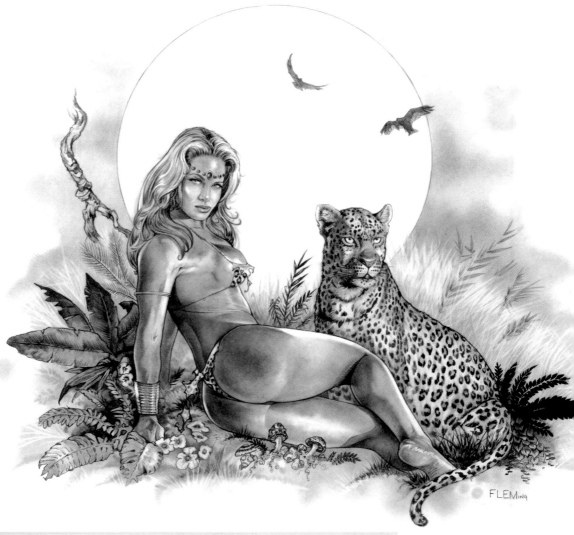

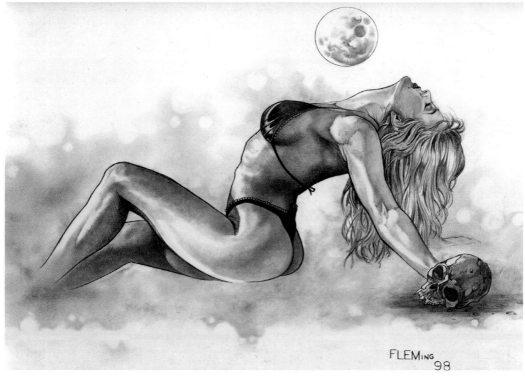

Recline

The very first drawing I ever did using blending stumps. The original was sold in an online auction in the early days of eBay.

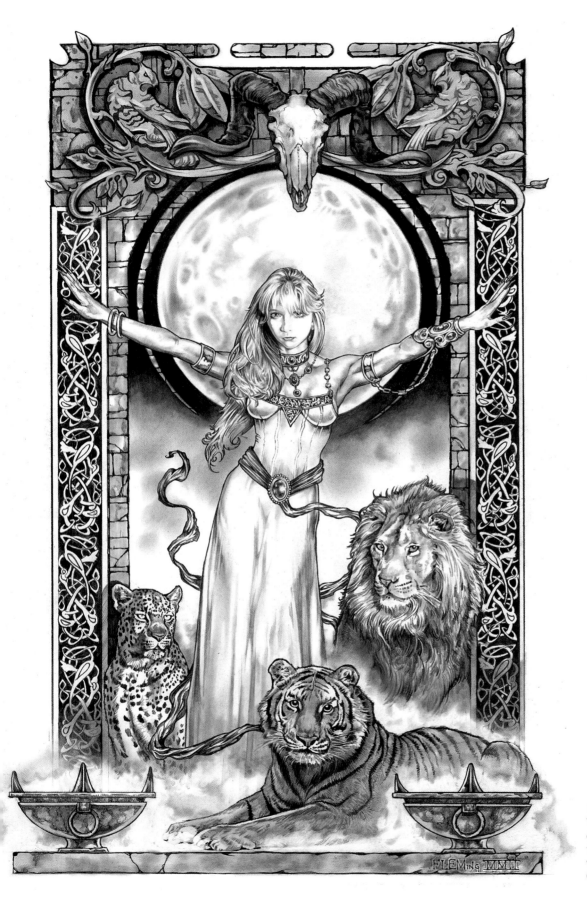

Lion Queen
This drawing was commissioned by a friend of mine for his wife as a very personal Christmas gift.

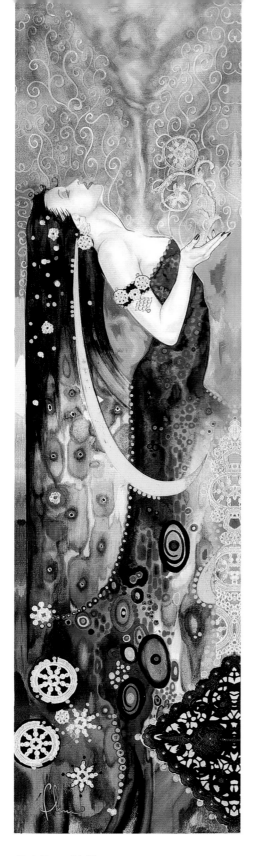

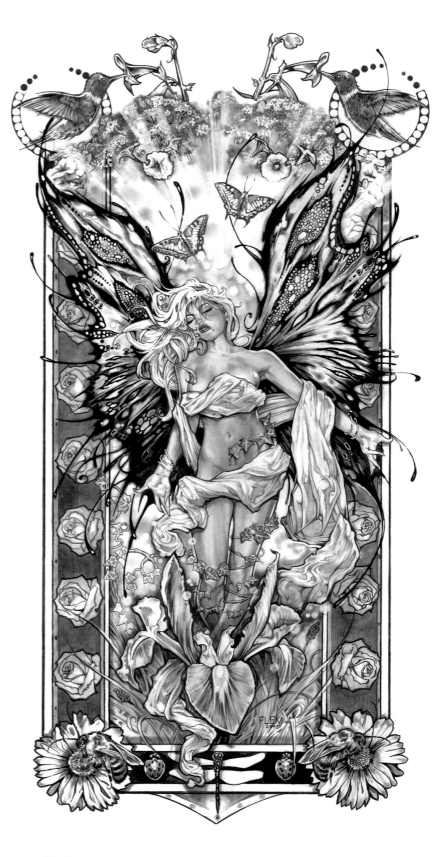

Spirit and Life

This is the first piece that I experimented with
appliqué, combining it with the influences
of Art Nouveau and my great admiration of
Gustav Klimt. I am very proud of this image –
it was nominated for a 2008 Chesley Award.

Spring

Of all my Art Nouveau-style pieces, this is
my favourite. This image was nominated
for a 2007 Chesley Award and is
available as a limited edition print.

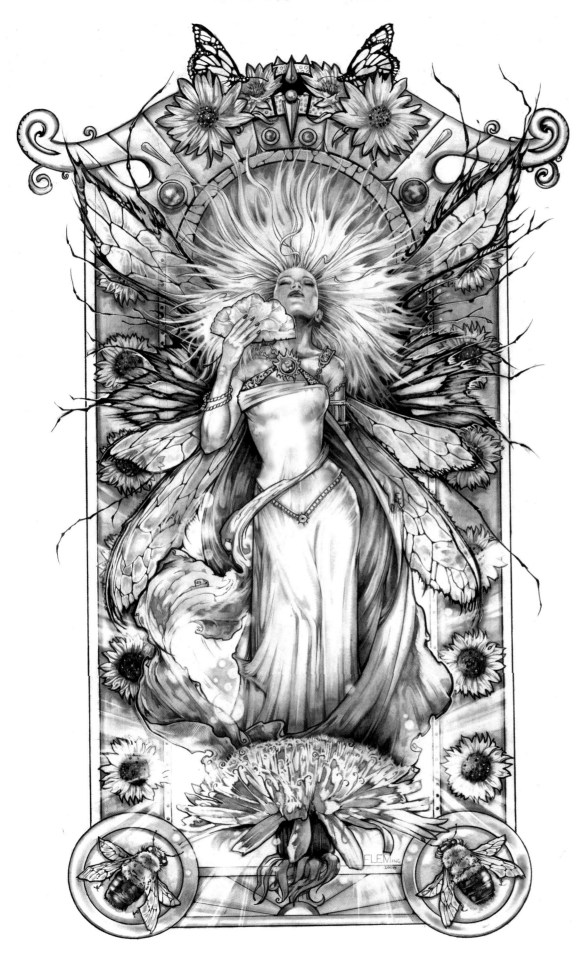

Summer

This monochrome piece captures the heat and intensity of the summer, all radiating from her burst of hair. This image was also nominated for a 2008 Chesley Award.

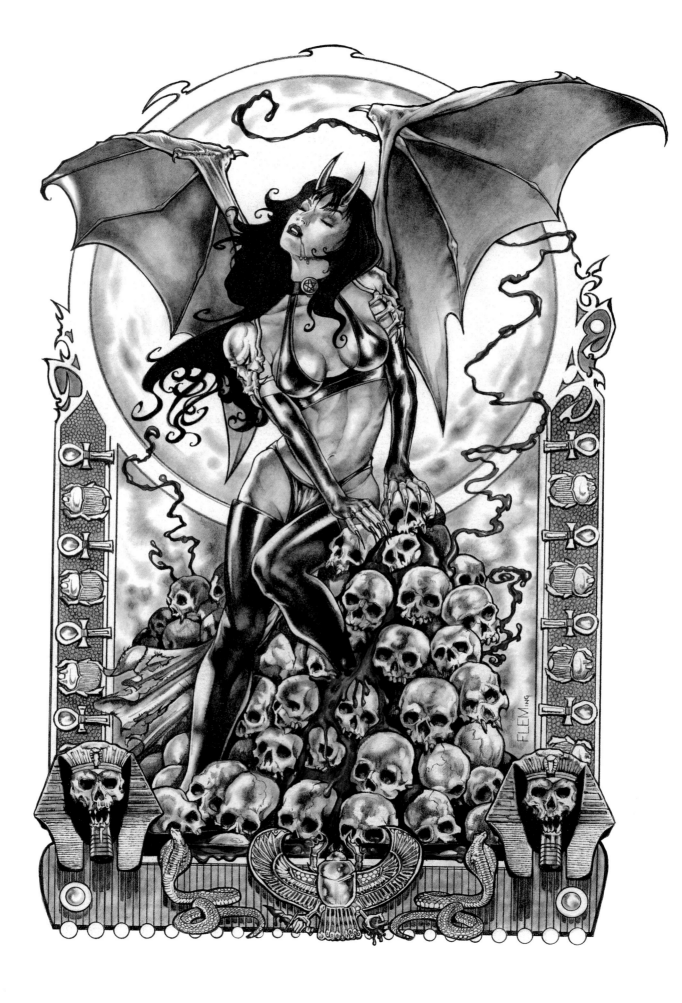

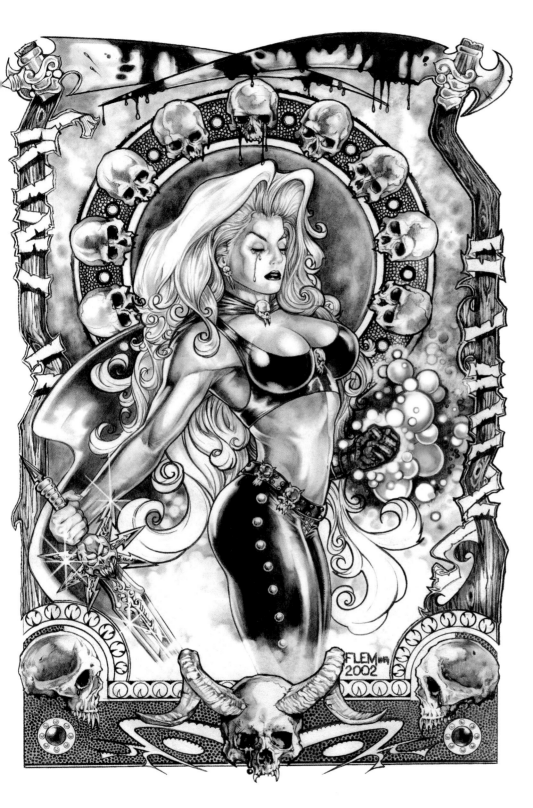

Lady Death

This image was created for the cover of 'Lady Death: The Mourning' #1 but both this and 'Purgatori' never made it to print due to the bankruptcy of Chaos! Comics. It has since become one of my best-selling prints.

Purgatori

Using a single colour against the monochrome is simple, but very effective. This image was created for the cover of 'Ravenous' #1.

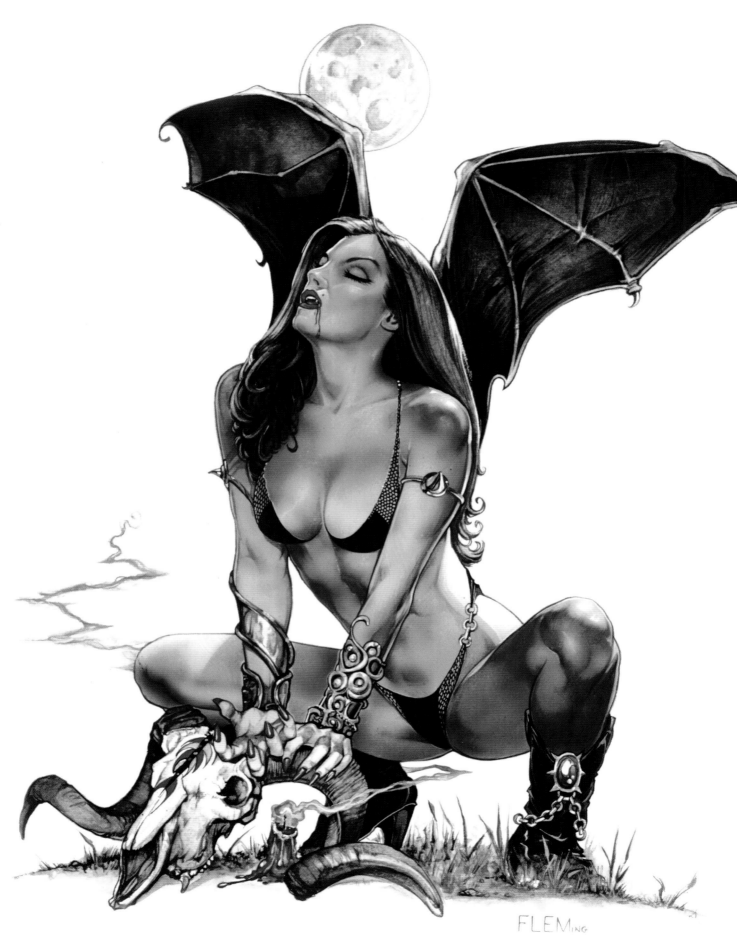

FLEMing

122

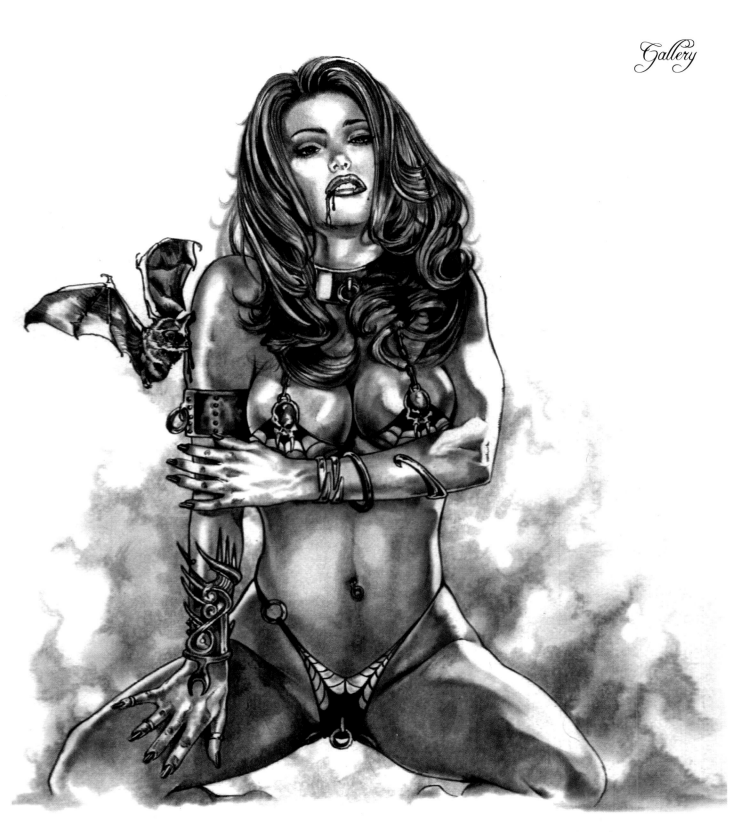

Ritual
This image was used as the back cover for *Heavy Metal* magazine, the back cover for SQP's *Crimson Embrace IV*, and the front cover of *Pin-Up Illustrated #1*.

Gothbite
An early pencil drawing combining pin-up and goth horror styles of art.

Heralds of the Storm
This paperback cover featuring Thea, was the first in a trilogy for White-Wolf Publishing. The 'Hello Kitty' design on her t-shirt didn't make it to the actual cover.

Soul Harvest
This is my depiction of the grim reaper as a female angel of death. This has largely become my signature piece appearing in major motion pictures, TV shows and on the cover of the iconic magazine, *Heavy Metal*.

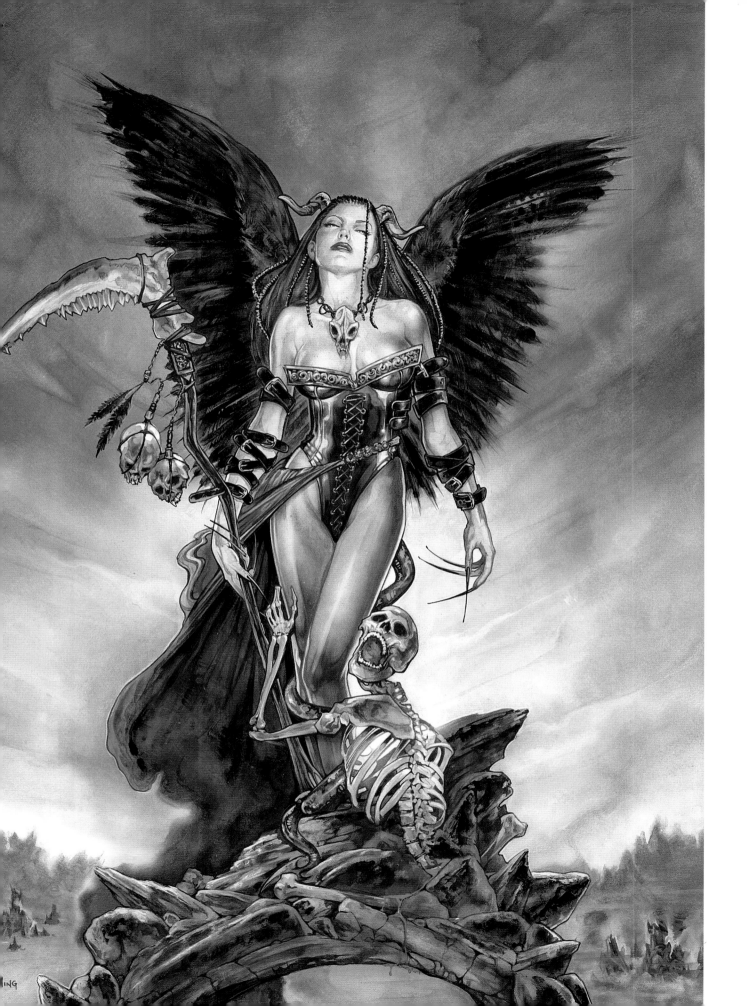

Acknowledgments

My heartfelt thanks go to my mother and father for giving me the foundation and opportunity to pursue my dreams early in life.

Thanks to Andy Wolf, Dave DeVries and Bill Harbort for being major creative forces in my life along with being great friends. Thanks to Jay Palefsky, Murray Tinkelman and Bob Dacey for going above and beyond the call of duty as teachers with their knowledge, insight and friendship.

Thanks to all my models throughout the years, and a special thanks to Devin Devasquez (www.devindevasquez.com) who has been unbelievably generous with her photos.

Thanks to the whole team at David & Charles for choosing and believing in me for this title. A big thanks to Freya Dangerfield for sincerely addressing all my concerns and being one of the most professional people I have worked with.

And thanks to Bugs Bunny, who I probably applied as a role model to a degree that was a bit less than healthy.

About the Author

Ever since he was a child, Tom Fleming knew that he wanted to be an artist. After graduating from high school in Putnam Valley, New York, he went on to receive his BFA from the School of Visual and Performing Arts at Syracuse University, graduating in 1988 at the top of his class.

In 1990, he landed his first full-time position as an artist/designer for the World Wrestling Federation by answering an advert in the *New York Times*. After three and a half years in this corporate environment, he decided to turn freelance. He immediately accomplished his childhood dream of painting comic book heroes, being commissioned by DC and Marvel Comics to illustrate his favourites characters such as Superman, Batman, Spiderman, The Incredible Hulk and The X-Men, along with fantasy characters for the card game, 'Magic: the Gathering', and the online game, 'World of Warcraft'.

In 1995, he moved to Wilmington, NC, and set up a home studio. He has since illustrated a diverse range of subjects including science fiction, fantasy, sports, wildlife, landscapes and advertising products, alongside his superheroes.

In 2000, Tom's talents attracted interest from the movie industry and he became the official illustrator for the Jodie Foster film, *The Dangerous Lives of Altar Boys*, with animation by Todd McFarlane. Since then, Tom has worked on films and TV shows such as; *Stateside*, *Stay Alive*, *Surface*, *Private Valentine* and the NBC hit show, *Life*. Tom's work has been featured in *Spectrum: The Art of the Fantastic* and has won numerous awards including three nominations for the prestigious Chesley Award.

Tom is now exploring the world of Fine Art and galleries with his award-winning Giclée prints and original art, while always looking for new licensing and business opportunities. For more information visit **www.flemart.com**.

Index

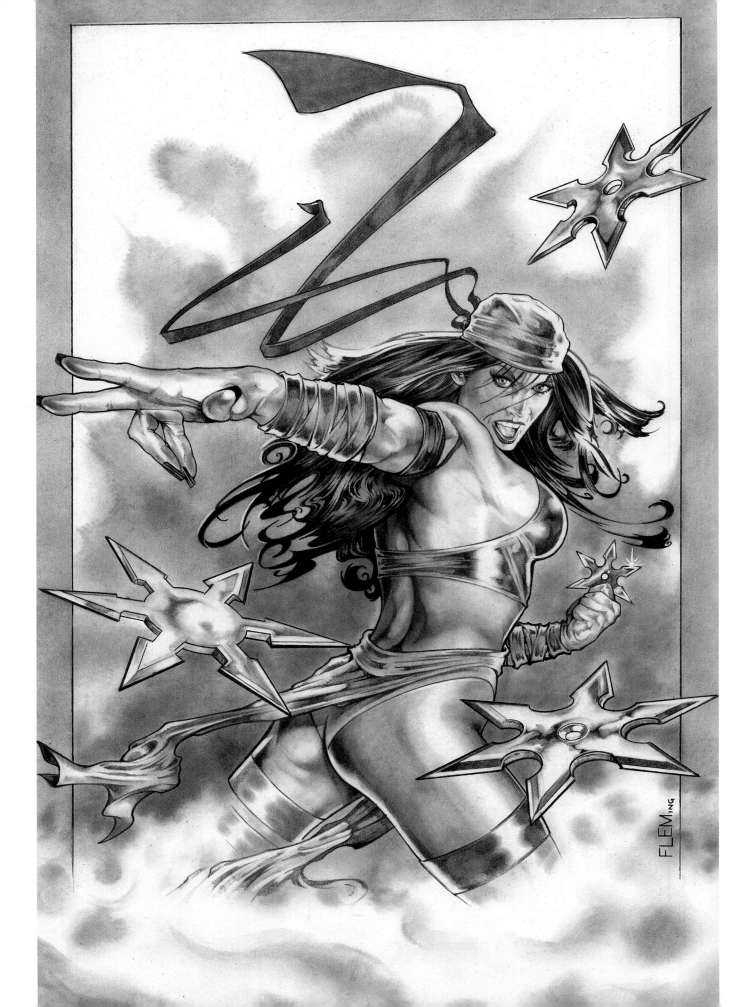